IMAGES
of America

MEEKER

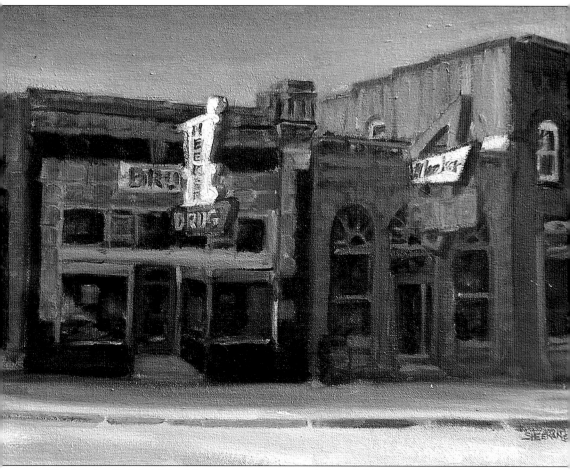

The Meeker Cafe brick building is an important and identifiable landmark in Meeker, inspiring artists even to this day, as evidenced by this painting by local artist Pat Sheeran Daggett. (Courtesy of Pat Sheeran Daggett.)

ON THE COVER: In 1891, a new post office was opened in this brick building on Market Street. The location subsequently housed a drug store, a grocery store, and the First National Bank starting in 1904. In 1917, the Meeker Café moved from inside the Meeker Hotel to here, where it is still in operation. (Courtesy of the White River Museum.)

IMAGES
of America

MEEKER

Kristin Bowen

ARCADIA
PUBLISHING

Published by Arcadia Publishing
Charleston, South Carolina

Printed in the United States of America

Library of Congress Control Number: 2014943793

For all general information, please contact Arcadia Publishing:
Telephone 843-853-2070
Fax 843-853-0044
E-mail sales@arcadiapublishing.com
For customer service and orders:
Toll-Free 1-888-313-2665

Visit us on the Internet at www.arcadiapublishing.com

This book is dedicated to those who came before us.

CONTENTS

ACKNOWLEDGMENTS

The author would like to thank all the families who have donated their treasured photographs to the historical society and museum, for if you had not, this book would not have been possible. No religious preference is implied by the selection of photographs, it just so happens that the Episcopal church had a minister who was a mighty fine photographer around the turn of the 20th century, and many of his works are included here. Historic *Meeker Herald* articles were used many times as a source of information. A very special thank-you goes out to all the women at the historical society and museum who helped provide me with information for this work. Thanks to my friends and family who helped me out in various stages of compiling this book. Thank you to the staff of the Museum of Northwest Colorado, who provided invaluable help, and to the US Forest Service and Bureau of Land Management staff who also assisted me. Thanks also to my father, Craig, and his love of adventure stories and history of the American West that developed my love of the same topics, which led to my career path and ultimately this book. Finally, to my son, Cooper, who deserves thanks for his love, support, and patience while I worked on this project.

Unless otherwise noted, all the images appearing in this book have been used with permission of the Rio Blanco County Historical Society and the White River Museum.

INTRODUCTION

The early history of Meeker is linked to the Ute, the Native Americans who inhabited the area prior to white settlement. An 1868 treaty imposed geographic limits on Colorado Utes and founded the White River Indian Agency, east of present day Meeker at Danforth Park. Ten years later, in 1878, Nathan Meeker was appointed the agent at the White River Agency; Meeker immediately began an attempt to turn the Ute into farmers. He moved the agency west of Meeker, in the area that is now called Powell Park, as he thought it would be more suitable for that pursuit. Meeker ordered the Ute horserace track to be plowed for farming. He hoped to change the lives of the Indians by turning them into farmers and making them settle down in one location, stopping their hunting-and-gathering lifestyle that led them to move around seasonally for available food. The Ute were enraged, as in their culture the horses were prized possessions and they had raced them in this field for years. Meeker sent a message to the Army at Fort Fred Steele in Wyoming asking for help as tensions rose.

Troops summoned from the fort, led by Major Thornburgh, were stopped at the reservation boundary at Milk Creek. When Thornburgh's troops trespassed onto agency land, a battle broke out in which his troops were eventually defeated. The Ute sent a rider back to the Indian Agency during the first day of battle and told the Ute there to kill Agent Meeker. All the white men at the Agency were killed and a fire was set that burned the agency down. Nathan Meeker's wife, Arvilla, and his daughter Josie Meeker, along Flora Ellen Price and her two small children, were kidnapped.

Help arrived on October 8, 1879, when Col. Wesley Merritt brought 1,000 soldiers, but by then the Ute were already leaving. He was given orders to build a cantonment called the "Military Camp on the White River" at the location of current-day Meeker. One hundred soldiers lived at the military camp until the fall of 1883 when an auction was held and all the buildings were sold to the early pioneers who had been moving into the area, and the Army departed.

In part to prevent a violent popular or state reprisal against the Utes, the Ute Removal Act and the Indian Bureau removed the Utes from all but the southwestern-most portion of Colorado, opening this area of northwestern Colorado to legal homesteading. Though largely removed to reservations in 1881, the Ute returned to the White River Valley every fall up through the early 1900s to hunt deer and trade with the settlers in Rangely and Meeker. Also, according to the Ute elder Clifford Duncan, who passed away in 2014, many Ute resisted and never moved permanently onto reservations.

Communities and post offices scattered across northwest Colorado began to incorporate as true towns after the removal of the Ute. An 1881 record lists a number of "towns" and post offices, including Axial, Lay, Maybell, and Rangely. The garrison constructed along the White River after the Utes' removal gave rise to the town of Meeker, Colorado, which was platted in 1885. In 1883, Garfield County was formed, covering what is currently Rio Blanco and Garfield Counties; the county was split in half in 1889 and Meeker was named the Rio Blanco County seat.

While there was limited extraction of Gilsonite, oil and gas, and coal, early Euro-American settlement of northwest Colorado was largely associated with livestock operations. The region supported both sheep and cattle grazing; conflicts between the two began in the 1890s, continuing through the early 20th century. The 1900 census listed the occupation of the majority of people in the county as farmer or farm laborer. A few were storekeepers, saloonkeepers, and managers of livery stables and hotels. There were a couple roustabouts, horse gatherers, gilsonite miners, and coal miners. A few of the more educated professions like lawyers and doctors also showed up; however, the majority had to do with livestock and agricultural pursuits.

Meeker has always been the business and banking center of a much larger community, spreading out in each direction from town. Hunting, fishing, and outdoor recreation in general as well as livestock raising were the main activities upriver from Meeker. Downriver, and spreading down to the Piceance Basin, livestock raising, hunting, and mineral extraction have been the dominant land uses.

Meeker and the surrounding community have remained, through ups and downs and booms and busts, and many remain loyal to this place. Like one of the earlier residents said in an interview for the *This is What I Remember* book series published by the White River Historical Society, "It is my hope that Heaven, if there be such a place, will be like the White River Valley I have loved so much."

One

1880s

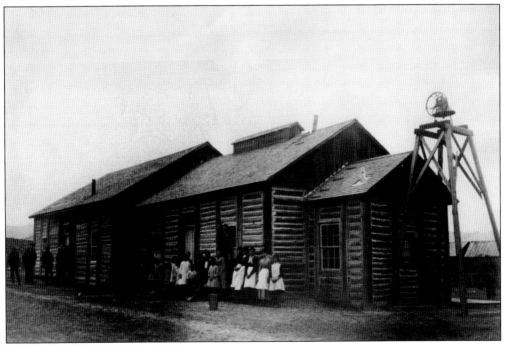

This c. 1887 photograph shows the government hospital that was constructed in 1880. After the soldiers left in 1883, the building was used as Meeker's first school up through 1889. The first year that the school was in session, there were five pupils in attendance and the teacher was Marry Hart Goff. The building still remains in Meeker as of 2014 and is used as a private residence.

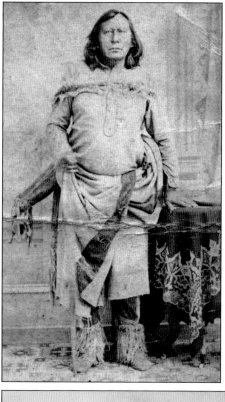

In 1887, Chief Colorow was involved in the last Ute war, which arose when a hunting party he was leading miles away from his Utah reservation was attacked by a gathered militia of locals sent to bring a halt to what was claimed to be Ute poaching. Colorow may have been fatally wounded during this battle; he died the following year in 1888. Many place names north of the White River and west of Meeker, like Colorow Mountain and Colorow Gulch, are named after him and are said to be areas he frequented. (Courtesy of the Museum of Northwest Colorado.)

In 1868, a one-armed explorer named John Wesley Powell spent the winter scouting the Green and White Rivers from his base in the area now called Powell Park. Powell warned that this was an area of great desolation and that irrigation would be required to be able to farm both of these river valleys. The area was named after him. The cabins he built there were present up through the early 1900s, when old-timers claim they washed downriver during high water.

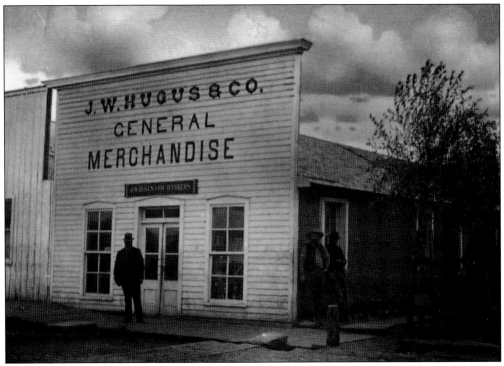

J.W. Hugus established a general store in Meeker in 1882, with J.B. Adams in charge. This first store operated out of an adobe barracks building that had a false front added on, as seen here in 1889 with Newton Major standing in front. A three-story brick building later replaced this store and was located on the corner of Sixth and Main Streets.

The first post office in Meeker was founded on September 29, 1871, with Frank W. Reynolds as postmaster. This early postmark is from March 1883, still prior to the town being founded. (Courtesy of the Museum of Northwest Colorado.)

This building was originally barracks for Army soldiers, and then held the first newspaper office of the *Meeker Herald*. The *Herald* was started here in August 1885 by John V. Houston and James Lyttle; in 1887, it moved to the corner of Fourth and Main Streets. These barracks were torn down and the International Order of Odd Fellows hall was built on the location in 1896.

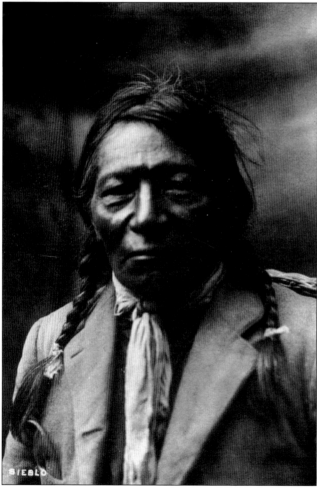

This photograph, taken by H.W. Samuels of Meeker, was titled "Sieblo." Sieblo was one of the Uncompahgre Ute who was designated to bring the White River Ute responsible for the attack on the agency to Washington, DC, for hearings. The party left the Los Pinos Agency on December 29, 1879, on horseback. The trip to the nation's capital was riddled with hostility for the party, as anger over the "Meeker Massacre" was boiling over in the state and nation.

This is Anna Mary Allsebrook's baby photograph. She was born to George and Celia Allsebrook on January 26, 1885, and is debatably the first Caucasian female born in Meeker.

Celia Allsebrook is holding her son, Bowen, in the doorway of their home in 1887. George Allsebrook bought this home at the 1883 government auction for $40. In the late 1880s, before moving on westward, he brought in one of the first herds of sheep, dug the first irrigation ditch, built the first flour mill in the valley, and served as the first superintendent of schools.

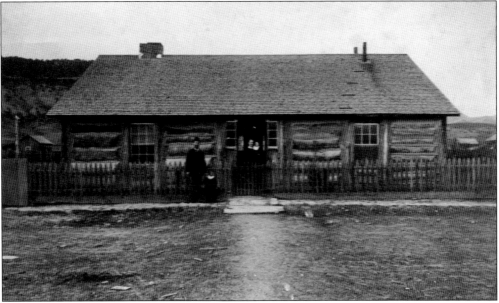

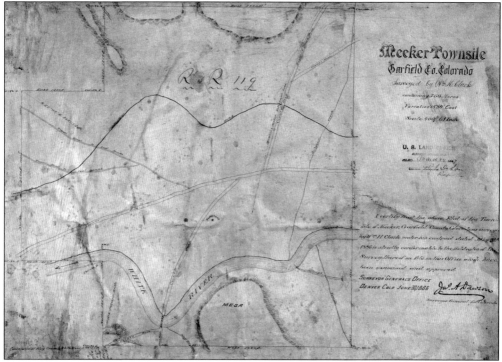

Meeker's town ditch was constructed by the Meeker Townsite Co. in 1884, and a year later, the Town of Meeker was incorporated, with William H. Clark elected as the first mayor. Clark was a surveyor and made this town plat map. The lots at that time sold for $2.63 each. Not many things appear on the map at this time, mainly a few roads and irrigation ditches and the Rawlins to Meeker Telegraph Line paralleling the Sulphur Creek Road.

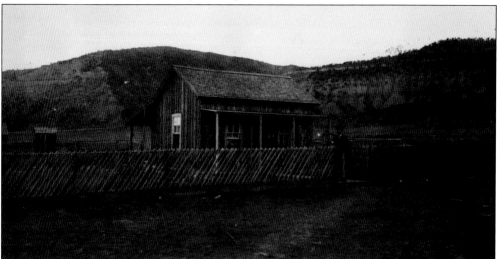

The John V. Houston residence is seen here in 1887; notice that no other houses are behind it all the way to the ridge known as China Wall. Houston came here from Leadville, Colorado, and with his partner, James Lyttle, established the *Meeker Herald* in 1885. After helping make the paper prosperous, he sold his interest to his partner and was appointed postmaster. Later, he engaged in the printing business, and by the early 1890s, he moved on westward and settled in Klamath Falls, Oregon.

This is a postcard of Chipeta, Chief Ouray's wife. When the hostages from the Meeker Massacre were brought to their home after their release, Chipeta cared for the women and children. On January 7, 1880, Chipeta and Ouray led a delegation of Utes to Washington, DC, to negotiate a treaty regarding a new reservation and to testify at a Congressional inquiry over the events at the White River Agency.

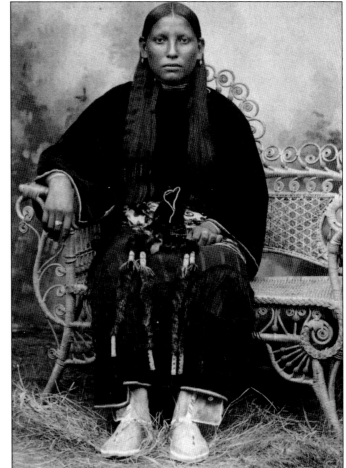

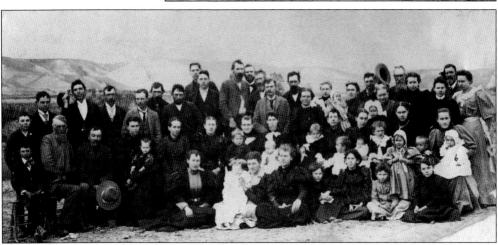

In July 1885, the Allen party, the largest single party to ever move into the valley, arrived in Meeker. The party is said to have consisted of over 50 men, women, and children, who arrived by a freight train of covered wagons. The *Meeker Herald* wrote an article noting the arrival of the party, which it said numbered 42, and each person was listed by name.

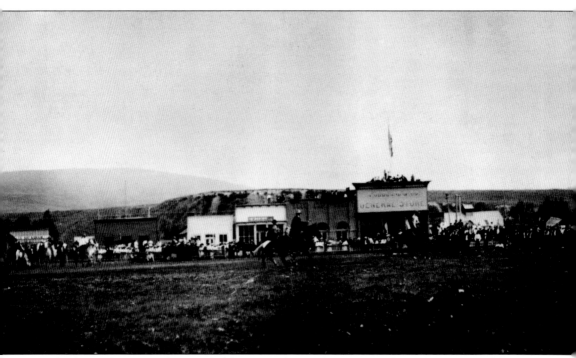

The first rodeo in Meeker was held in 1885 during the town's Independence Day celebration, and has continued every year since during the Fourth of July festivities, making it the oldest continuous rodeo in Colorado. This photograph is from the first rodeo, held in the two adjoining parks in the center of town. The downtown businesses on Main Street can be seen in the background. Spectators are on the roofs of several buildings, and also line the white picket fence circling the park.

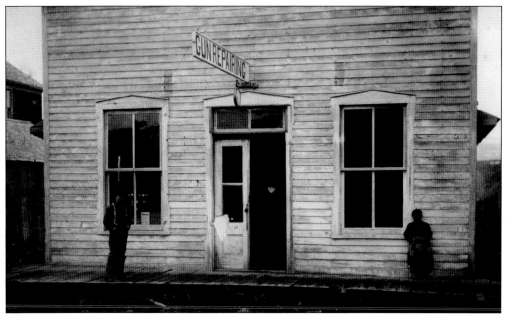
A gunsmith shop is shown here on the east side of Main Street in the late 1880s, when all the businesses in town basically fit on the eastern side of two blocks of Main Street.

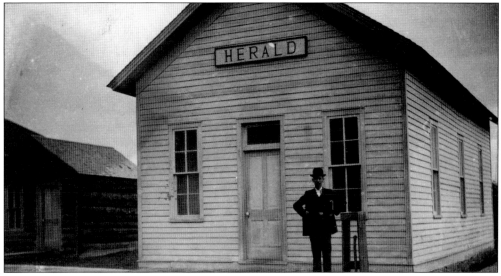
This is the *Meeker Herald*'s first frame building, which was the first frame business building in town, on the corner of Fourth and Main Streets in 1888. Editor and cofounder James Lyttle is standing out front.

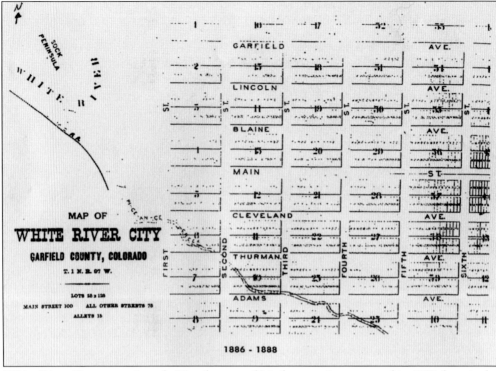

White River City, approximately 20 miles east of Meeker, was incorporated in 1888; here is the original town plat drawn up that year. Ambrose Oldland was involved in oil speculation in this area as early as 1889 and was involved with establishing White River City with his brother Reuben Oldland. It was speculated that the area would be a growth center, and a railway to the area was anticipated. (Courtesy of the Museum of Northwest Colorado.)

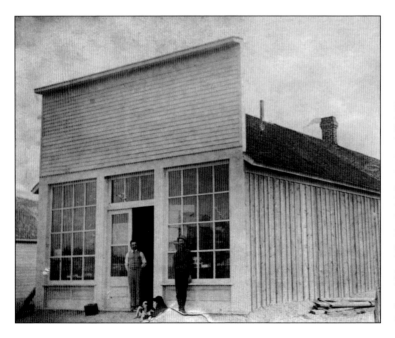

Ambrose Oldland, hailing from Gloucester, England, built his first store in the spring of 1888 in White River City on Piceance Creek. He ran this store until 1895, when he moved to Meeker and purchased the Watson General Store with his brother, Reuben, and renamed it A. Oldland & Company.

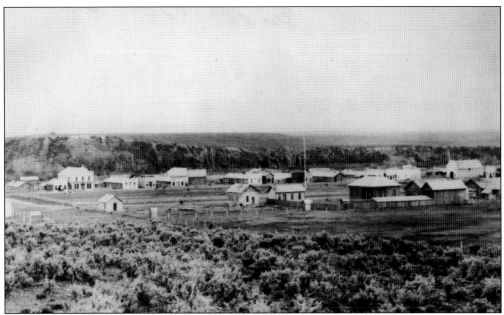

This is an overview of the town of Meeker. The photograph can be dated between 1887 and 1890 because Antlers Hotel, which was built in 1887, is visible, but the porch that was added onto the building in 1890 does not exist yet.

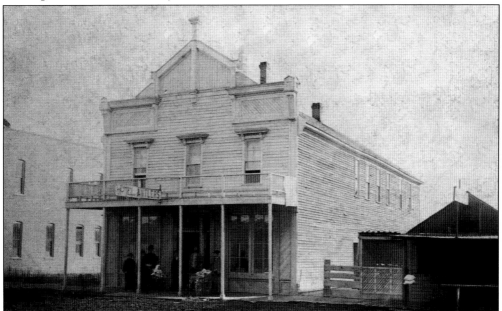

Antlers Hotel was built in 1887 by Edward Stanhope Render Sanderson, better known as E.S.R. Sanderson; this photograph of Antlers was taken a few years later in 1890. Sanderson constructed this building at the same time he was constructing Sanderson Hall, a community building intended to be used for multiple purposes, one of them as an opera house. It was likely built for his wife, Amy, an opera singer, though opera never turned into a lasting attraction in Meeker. Looking forward to the hall's opening, the *Meeker Herald* wrote that the building would "meet the general approbation of lovers of terpsichore."

This is one of the first residences in Meeker, the home of Newton Major, seen in 1880. After Major lived here, Arthur C. Moulton, better known as A.C. Moulton, lived in the house in 1889–1890 while his house was being constructed farther up the street. The Major home was later torn down.

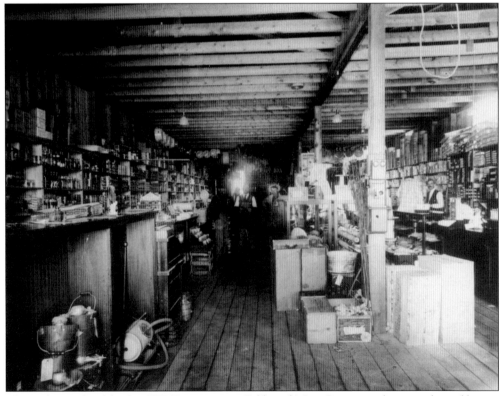

This is the inside of the first J.W. Hugus store at Fifth and Main Streets, with exposed wood beams on the ceiling; the date of the photograph is unknown.

Two

1890s

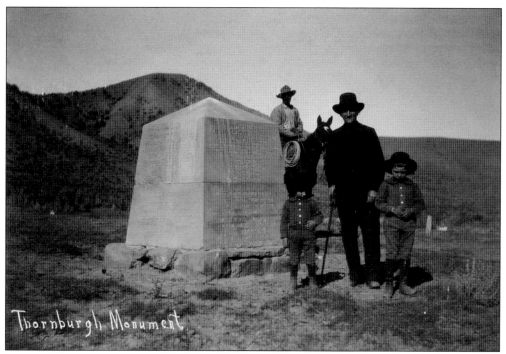

Thornburgh Monument

Dave Kern is on horseback while brothers Raymond Durham (left) and Harry Durham, and their maternal grandfather, C.J. Dickinson, are standing next to the Thornburgh Monument north of Meeker in 1893. This monument was erected on the Milk Creek Battlefield during the time of the military encampment on the White River to commemorate the soldiers who died there. The Durham family homesteaded the land after the Ute were removed to Utah. (Courtesy of the Museum of Northwest Colorado.)

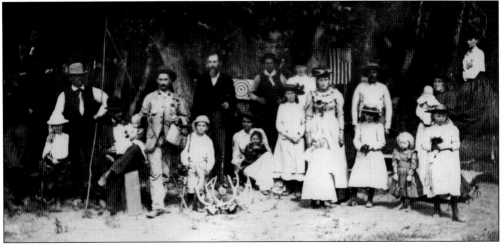

This photograph was identified simply as the Metzger, Hartke, and Wildhack families at a picnic in 1894. However, nothing seems simple about this family picnic composition, complete with American flag and antler decorations, fine attire and flowers, fishing gear, and bull's-eyes on trees.

Incorporated Under the Laws of the State of Colorado.

No. 7 1 Shares.

THE RIO BLANCO NEWS

PUBLISHING ✦ COMPANY

CAPITAL STOCK $1,100....TWENTY-TWO SHARES AT $50 EACH.

THIS IS TO CERTIFY, That *G. D. Thayer* is the owner of *one* share of Capital Stock of the RIO BLANCO NEWS PUBLISHING COMPANY, full paid, transferable only on the books of the Company, in person or by attorney, on surrender of this certificate.

Meeker, Rio Blanco County, Colo., *January 16# 1890*

Morgan Edgar President. *Henry A. Wildhack* Secretary.

This 1890 stock certificate represented one share of capital stock of the Rio Blanco News Publishing Company sold to G.D. Thayer. The *Rio Blanco News* was founded by J.A. Burgett and was published from August 1889 to October 1891. In 1892, part-owner Henry A. Wildhack bought out the *Herald* from James Lyttle and the two papers merged. The combined papers were briefly known as the *Meeker Herald and Rio Blanco County News* before reverting to the much shorter *Meeker Herald*. Lyttle bought the *Herald* back shortly after he sold out and ran it for a long time. (Courtesy of the Museum of Northwest Colorado.)

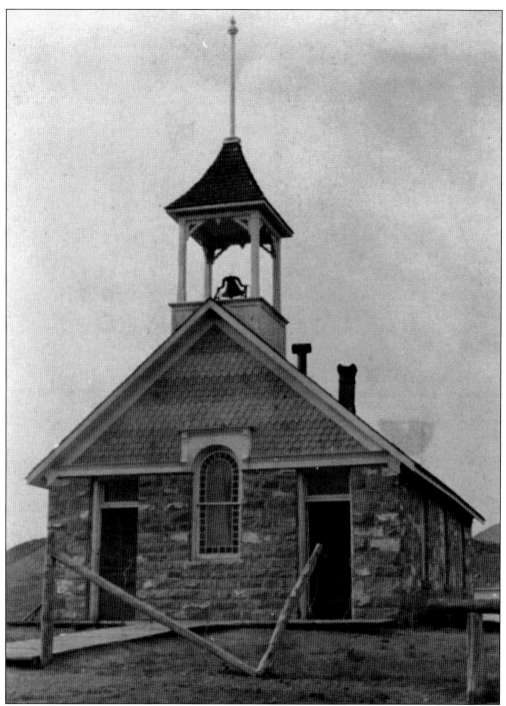

The Coal Creek School, four miles east of town, was established in 1884 and is the oldest rural school in the area. The building pictured was constructed in 1892. The bell from this belfry is now on display at the White River Museum. The school building still remains and was placed on the Rio Blanco County Historic Preservation list in 2013. (Courtesy of the Museum of Northwest Colorado.)

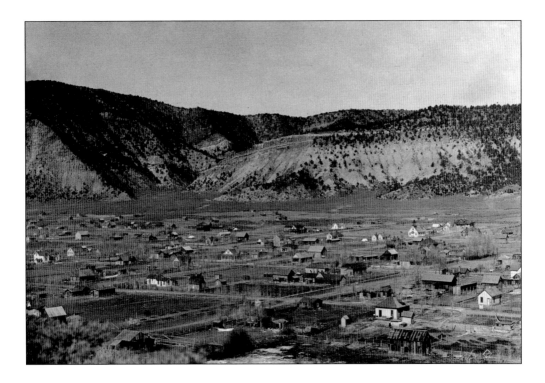

Both of these photographs are overviews of Meeker taken in July 1893.

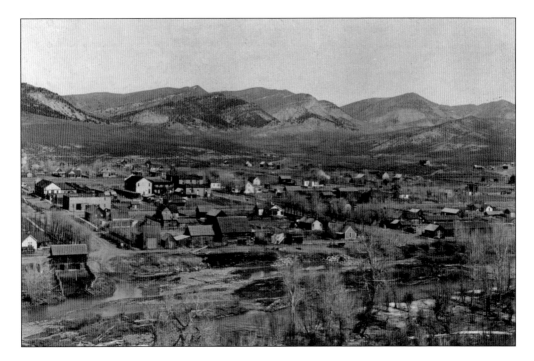

The IOOF hall at the corner of Fourth and Main Streets was erected in 1896. The Independent Order of Odd Fellows was one of the first fraternal organizations in Meeker, along with the Masons. Here, the Woodmen of the World are posing outside the building, not the Odd Fellows. The Woodmen, another fraternal organization, used the hall for their meetings, as did other groups. There were many fraternal organizations in Meeker in the early days, as at that time membership in one was considered essential to a man's political advancement.

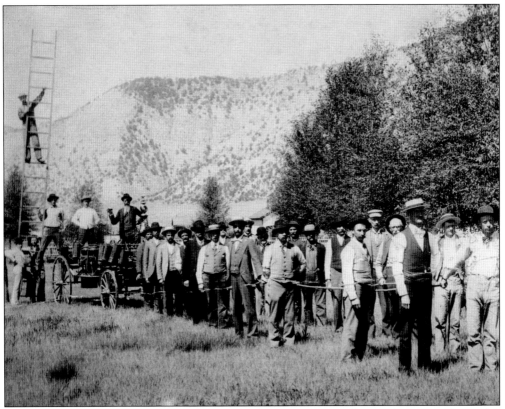

Here are Meeker's first firemen, identified from left to right as James Lyttle, Q.B. Kelley, Ed P. Wilber, Olar Walden, W.E. Simpson, Dr. W.E. Young, William H. Clark, Henry A. Wildhack, Eugene Gilley, Keno Imes, Henry H. Hay, E.F. Fordham, Thomas Shervin, A.C. Moulton, Maurice Driefuss, Sigmund Forges, Ambrose Oldland, Hiram Perry Spurlock, W.F. Morton, Rienhold Hartke, Aldoph Pflug, L.B. Walbridge, M.T. Ryan, Reuben Ball, Victor Dikeman, and W.M. Fairfield.

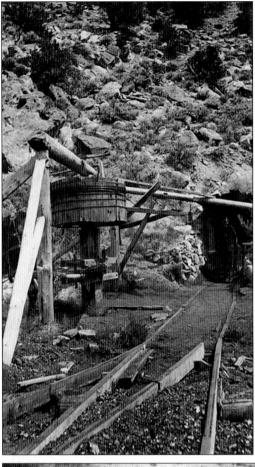

The Fairfield Mine operated as one of the early coal mines near Meeker. The Hayden Survey in the mid-1870s noted that this region contained coal, and that oil and oil shale could be found in the Piceance Basin. (Courtesy of the United States Geological Survey.)

A group of Meeker folks are out recreating in 1890 at the Fairfield Mine, which was about a mile southwest of town on the north side of Highway 13 before the Highway 64 turnoff.

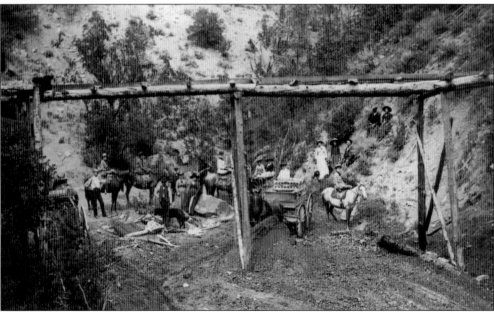

No caption is needed for this whimsical pair.

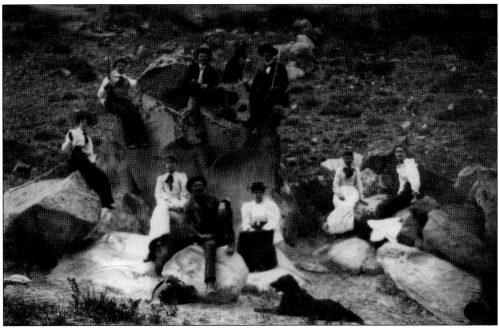

This was taken near the coal mine of Coal Creek. From left to right are (first row) Hattie Mootz, Simon Mootz, Carrie Mootz, Mrs. Mootz, and Nannie Ball; (second row) Edna Booth, J.B. Kelly, Victor Dickman, and Reuben Ball.

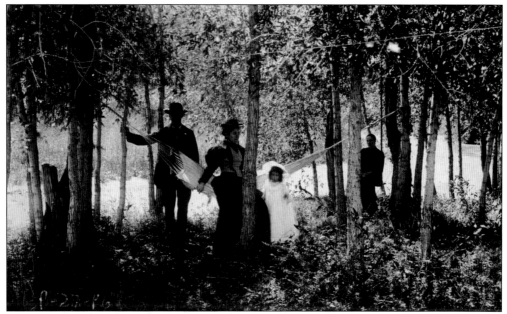

Lucy Jane Crawford and her husband, Robert Crawford, are at a picnic; Annie Wildhack is on the hammock and her eldest daughter, May Wildhack, is the girl in white who is out of focus. This photograph was taken at the McHatton Ranch west of Meeker in 1896.

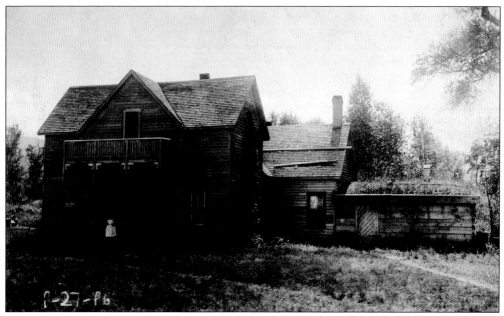

Lucy Jane and Robert Crawford are with Annie and May Wildhack at the McHatton Ranch west of Meeker in 1896. Notice the sod roof on the right.

This photograph was likely taken in the 1890s, when bicycles first made their way into this region and were mainly owned by the upper-middle class. This may be David Smith, who was the first person in Meeker to own one; he was known to ride it to work.

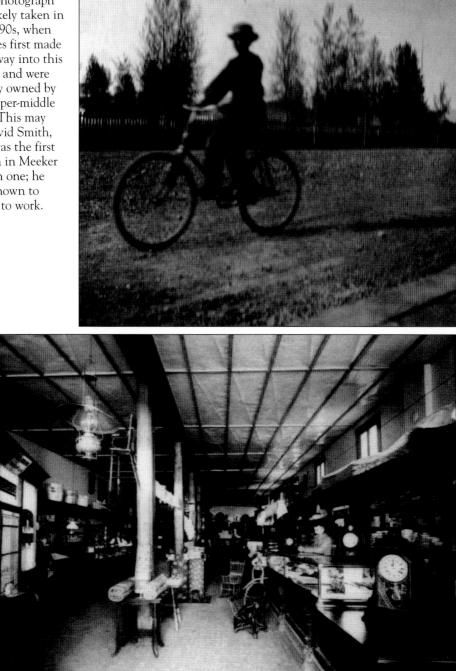

The J.W. Hugus store on the bottom floor of the first brick building at Sixth and Main Streets is seen here around 1900. C.A. Booth is on the right, working behind the counter. This store building was constructed in 1890 and operated until it burned down in 1911. The Masonic lodge was above the store on the second floor; they moved their meetings elsewhere after the fire and then moved back in once the replacement building was constructed.

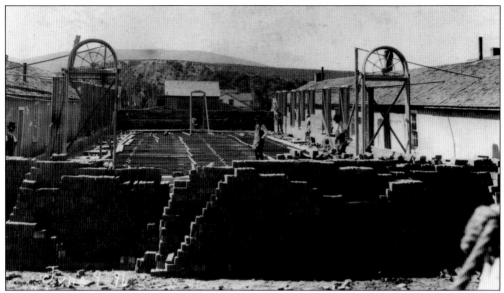

The White River Museum has an eight-photograph series that documents the construction of the Meeker Hotel at 560 Main Street in 1896. These four photographs are part of the series taken every few days showing the construction progress. The first shows an enormous stack of bricks piled in front of the building and the beginnings of the wood framework for the windows.

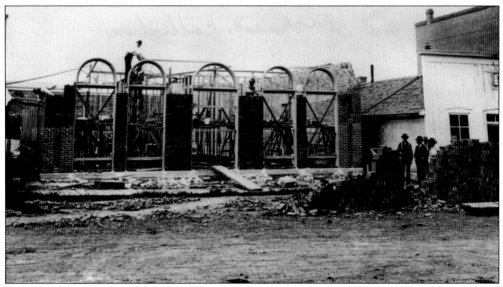

This is the third in the series of photographs documenting the summer of 1896 construction of the Meeker Hotel. On June 17, 1896, the wooden facade openings with arched transoms are set, and masons proceed with brickwork between them. Stacks of bricks still remain out front.

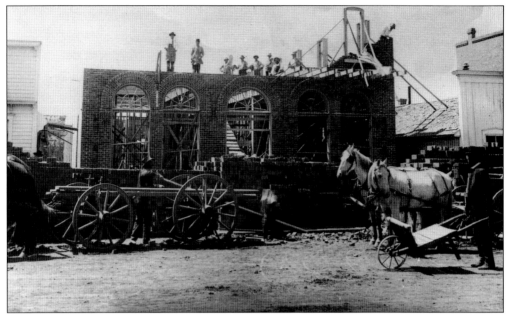

In the fourth photograph, taken on June 25, the brick and window work is continuing on the second level. Workers pose on the upper story for the photographer. A freight team is out front, as well as a man holding a wheelbarrow, likely unloading more supplies for the construction efforts.

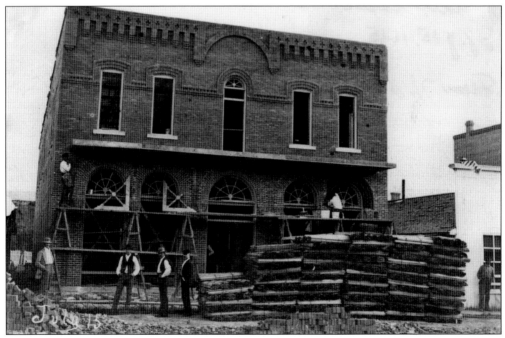

Here is the sixth photograph in the series, taken July 7, 1896, about a month into construction. This facade view shows that the brickwork is near completion on the two-story hotel, with two men posing on scaffolding.

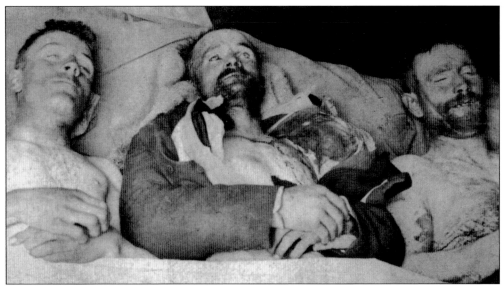

On October 13, 1896, the Wild West came to Meeker when three gunmen attempted robbery of the Meeker Bank, J.W. Hugus General Store, and post office, all of which were in the same building. As a result of their firing shots at the bank teller during the attempt, the townspeople were alerted and the gunmen were swiftly killed by the armed citizens of Meeker. In the excitement of the day, the local saloons served drinks on the house all night long.

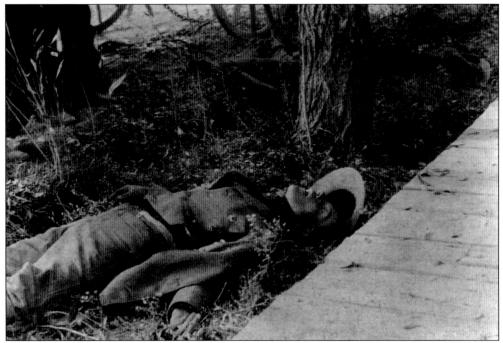

Bank robbers "Kid" Pierce and Jim Shirley (behind the tree) lie where they were gunned down by Simp Harp and Frank JoHantgen as they bolted from the bank, guns ablaze, dashing for their horses. George Law was then shot as he fled down the street after he witnessed his comrades fall. All three are buried in Highland Cemetery. Not until 2012 did someone try to rob a bank in Meeker again.

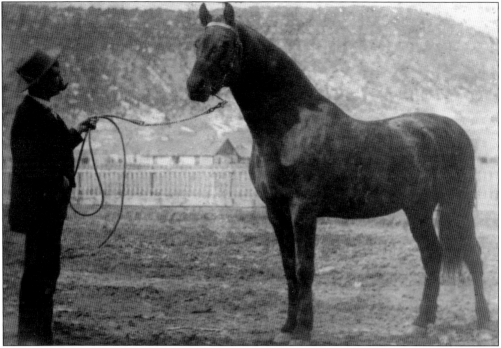

Horace Simpson Harp, known by everyone as "Simp," is seen here in 1898 with his stallion. Simp arrived in Meeker in 1888 and started a livery business and, later, a stage line. Simp was the first person in Meeker to purchase an automobile, and when he arrived with it in 1904, it caused quite a stir.

Here is a Coal Creek school program from the 1896–1897 school year, when Mrs. Henrick was the teacher. The kids are dressed up representing different nations. From left to right are Daisy Warren, Harry Durham, "Tot" Wilbur, Raymond Durham, Nettie Robertson, Harry Pollard, Jessie Warren, Luther Smith, and Jack Bloomfield.

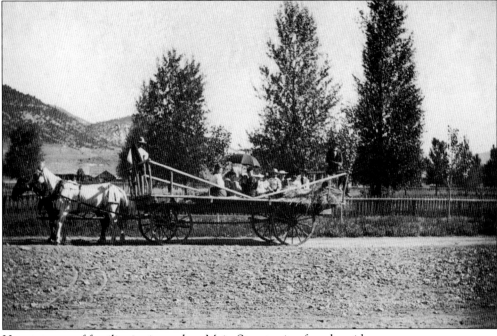

Here, a group of families is pictured on Main Street going for a hayride.

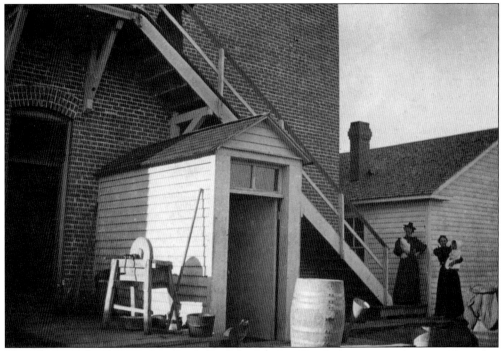

This photograph, taken in the alley behind the Meeker Hotel, shows a grindstone and a water barrel behind the building. All water for use in the hotel was hauled in by freight teams, who would unload these barrels in the back. The town water system did not come until the next century, and until townsfolk had running water, they either hauled it from the river themselves or paid the waterman for the service.

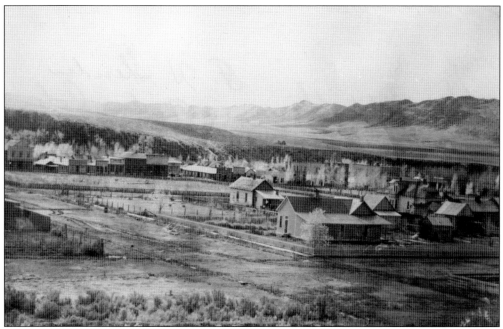

In this overview of the Meeker business district in the late 1890s, Antlers Hotel is present and most of the buildings have false fronts. The only brick business on Main between Fifth and Sixth Streets now is the Meeker Café. Brick structures held significance at this time. Since wood structures were more susceptible to fire, brick structures meant the town was going to stick around.

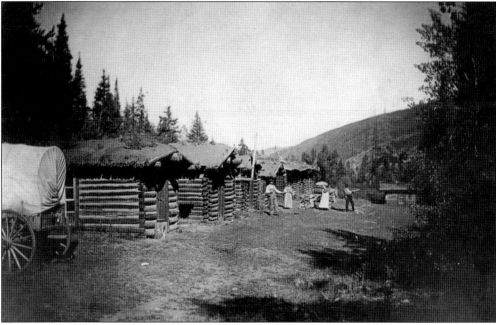

Marvine Lodge is seen here in the late 1890s. Billy Green, his wife, Cora, and their daughter Isabell are seen outside the sod-roof cabins. Green was a cowboy, tourist guide, and caretaker for the lodge. The Greens, like many who ran lodges for tourists, spent their winters in town and summers at the lodge.

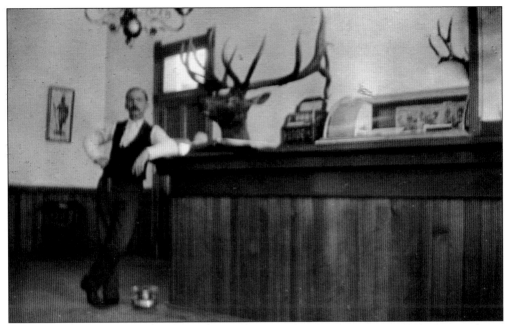

The Meeker Hotel was originally established in an adobe building that had first served as a military barracks. Partners Charlie Dunbar and Susan Wright purchased the original building in 1884. Charlie was killed in an argument over a card game a few months after the opening of the hotel. Susan's brother, Reuben Ball, went to work for her in 1891, and when she died in 1893, she willed her estate to him; he is pictured here inside the hotel.

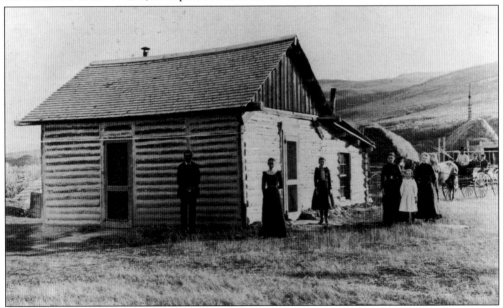

Seen here in the late 1890s or early 1900s is the ranch house of Hiram W. and Jennie Tomlinson, up County Road 8. Hiram W., better known as "Wes" Tomlinson; Jennie Tomlinson; and Clara, Ida, Elsie, and Gertie Metzger are pictured here in front of the house with John Kircher and boys in the wagon in the background. This ranch was bought by John Smith in 1914 and later owned by Margaret Smith Isaacs.

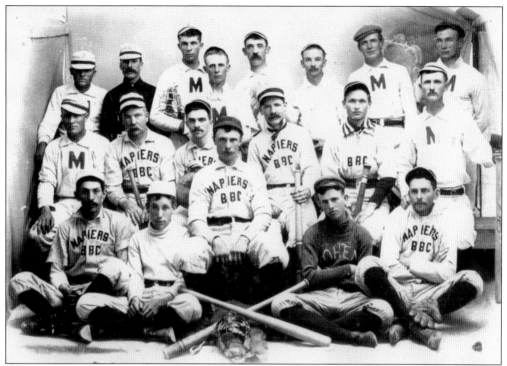

The first Meeker baseball team played against Glenwood Springs July 3–4, 1898; both teams are pictured here in uniform.

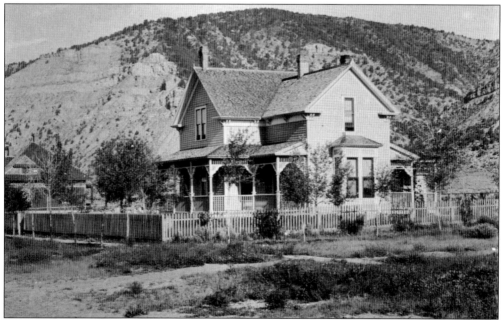

This classic example of 19th-century home design is the Lyttle House, built by James Lyttle, owner and editor of the *Meeker Herald*. His son, Richard G. "Dick" Lyttle, took over and ran the *Herald* almost as long as his father did, and lived in this house after his father as well. While at the *Herald*, he doubled the size of the plant and bought a modern Linotype press in the 1950s.

Edith Strehlke and Effie Trelease are seen dressed up for the *Merry Milkmaids* play. *The Merry Milkmaids: An Amateur Operetta In Two Parts* was written in 1891 by Chas. H. Gabriel. The author's note in the original text stated his intent of the operetta was to "give young people (in and out of the Church) an altogether pure, chaste and wholesome entertainment."

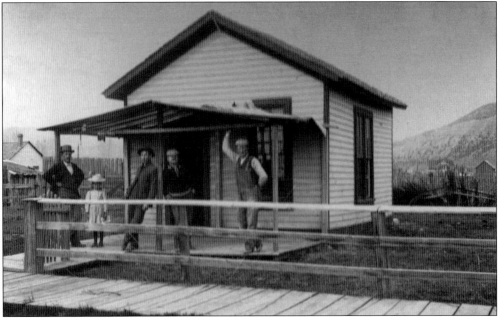

This photograph of Meeker's barbershop quartet was taken on Sixth Street mid-block on the west side north of Main Street in 1899. Identified by prior historical society members are, from left to right, G.B. Kelley, May Wilhack, Tom Cassidy, ? Phiefer, and ? McCarthy. However, on the back of the photograph, another historical society member had written than Johnny Welch was the piano player at far right, not McCarthy.

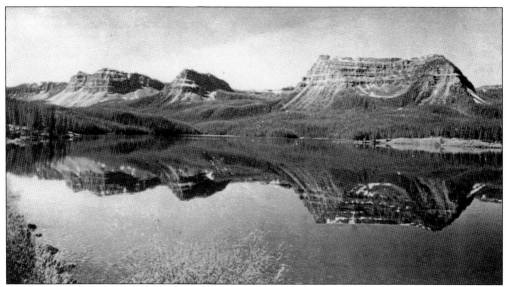

Trapper's Lake, one of the special gems of the forest, was well known but undeveloped around 1900. In 1919, the Forest Service sent Arthur Carhart to lay out plans for summer cabins and a road around Trapper's Lake. Carhart returned to Denver with a new perspective on land management and managed to get the Forest Service to agree to leave Trapper's Lake in its pristine condition.

The White River Timberland Reserve was created by law in 1891, the second such reserve set aside in the United States. The Ute Creek Ranger Station was constructed as the supervisor's quarters for the Sleepy Cat Ranger District of the White River Timber Reserve by Supervisor P. Randolph Morse, who served in 1900 and 1901. It is one of the oldest ranger stations in the United States. (Courtesy of the United States Forest Service.)

This photograph, taken by Reverend Handel and titled "Our Sherriff," shows an effect broadly called "vignette." A traditional vignette looks like blurred edges around a clear center; the distortion is caused by a camera lens being unable to focus and distributing light evenly across the plane. The framing seen here is an attempt to mask that by essentially reversing it, creating a hard edge that forces the viewer to focus on the center. The term originally referred to a lithographic design in the form of vine tendrils around the borders of a book page and means "little vineyard" in French.

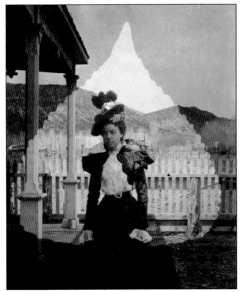

This photograph by C.A. Booth is of his daughter Edna Booth and shows vignette framing. It was created by placing a reverse frame over the image center in the darkroom, resulting in the perimeter being "burned" and darker than the normally exposed center of the photograph. Burning is a photography term meaning overexposing or making darker; the opposite, underexposing or making lighter, is called dodging.

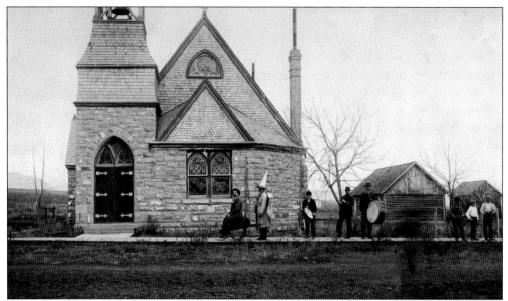

Robert Van Wyck won the election to be the first mayor of New York City when all five boroughs were joined to make one city in 1897. This scene is the result of a lost wager on that landslide election. One of the founders of Meeker, William H. Clark, is in the wheelbarrow being pushed by J.B. Hill Riding, who is wearing a dunce cap. They are followed by several people marching with drums to draw the attention of anyone who may have otherwise missed the spectacle.

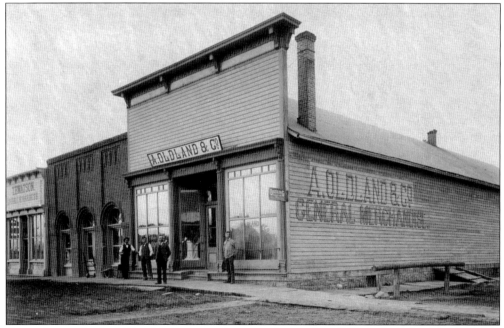

Shown here is the A. Oldland & Co. general store in the very late 1890s with Ambrose and Reuben outside. The obvious false front on the building, the wood boardwalk lining the businesses on Main Street, and a hitching post outside the store are also visible. The small sign on the storefront reads "Deering Harvesting Machinery." Deering merged with four other companies in 1902 to become International Harvester.

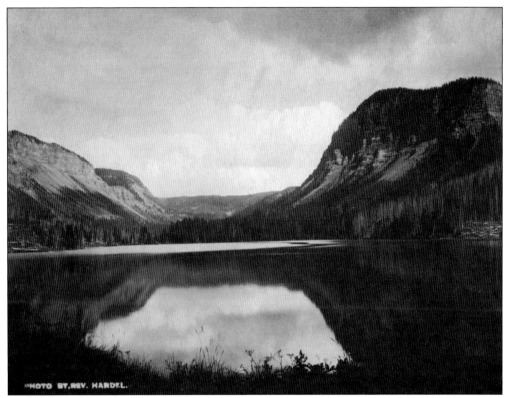

PHOTO BY REV. HANDEL.

Above is a scenic photograph of Marvine Lake taken by Reverend Handel, and on the left are children at the Marvine Lodge Resort. Both pictures were taken around the turn of the 20th century, when the area had turned into a tourist destination. The resort, run by John Goff, was widely known to sportsmen as a big game hunting center by this time. A post office was organized at Marvine in 1895.

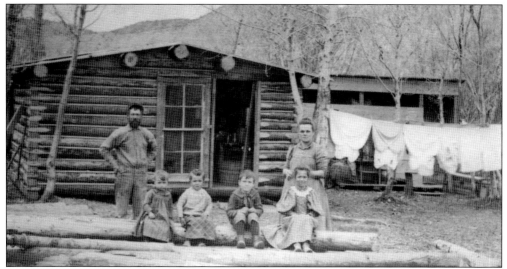

This image shows the Kincher family at their modest log home down by the river, with their laundry hung out to dry. From left to right are John, Lotta (short for Charlotta), Harry, Arthur, Netta (short for Annetta), and Otillie.

This was the home of A.L. Durham, which he built in 1898, though Durham homesteaded the Milk Creek Battlefield before 1898; he also worked for the railroad and for Charlie Perkins. This gorgeous home still stands on the corner of Garfield and Sixth Streets.

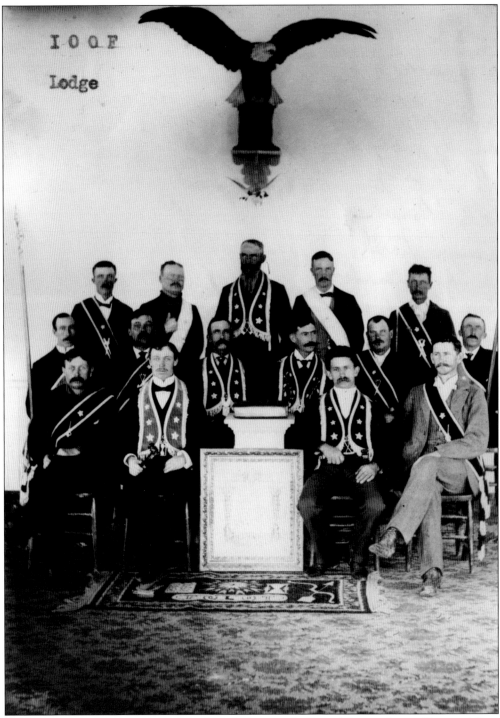

Here, IOOF members are posing for a formal photograph. From left to right are (first row) Bert Howey, J.L. Tagert, Reinhold Hartke, and Reuben Ball; (second row) George Lord, Frank Clark, T.D. Riley, Frank JoHantgen, Lark Craig, and unidentified; (third row) unidentified, Herman Pfiefer, Dr. Young, J.B. Kelly, and unidentified.

Three

1900s AND 1910s

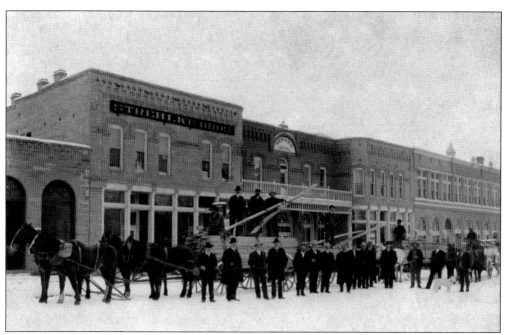

In front of the downtown "Brick Block" is a team of horses pulling drilling equipment headed to the Rangely oil field. The Rangely field was developed by the Texas Company in 1933; however, early development there started at the turn of the 20th century. The equipment shown here was destined for the Requiem Well No. 2, which was drilled in the early 1900s.

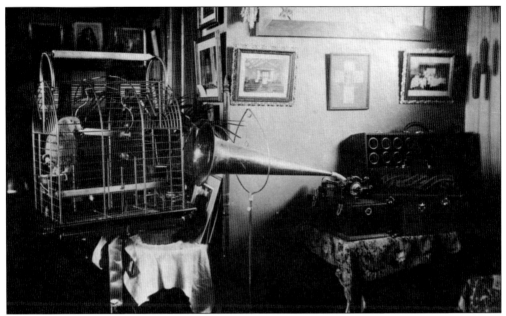

In 1896, the Edison Home Phonograph was first produced. Here, Reverend Handel of the Episcopal church, around 1899 or 1900, is playing one for his bird in a photograph he titled "Teaching Polly English." The reverend purchased this phonograph with his own money and people came from all around to hear the talking machine.

This token is stamped "Meeker Hotel" on one side and "Good for 12 1/2¢ in Trade R.S. Ball" on the other side. Trade or barter tokens were used in place of currency for exclusive use at specific retailers or organizations. They were given away for promotional purposes, sold for value, earned in exchange for labor, and could be used for things such as bar tabs, food, rooms, and other such purchases. The height of their popularity was between 1870 and 1920. The denomination of 12.5¢ is one bit, a term known now more in rhymes than actual usage. (Courtesy of the Museum of Northwest Colorado.)

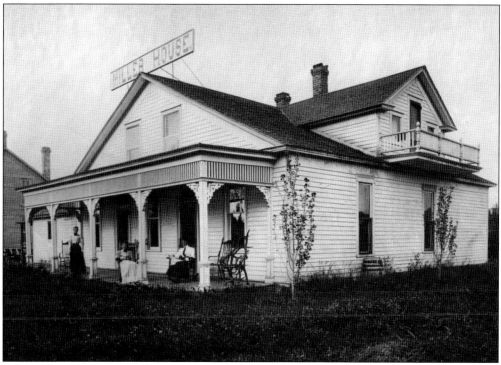

This is the Miller house, a boarding house that was built and run by Sarah Miller. The family of David Enoch Cunningham came here in September 1915 when they bought the house. They ran it as a boardinghouse as well for decades. It served as more than just a hotel; it had permanent boarders, people came here to eat meals and play cards, and Lions Club meetings were held here. In 1887, the *Meeker Herald* said the Miller House, where meals cost 35¢, was the best place to stop in Meeker.

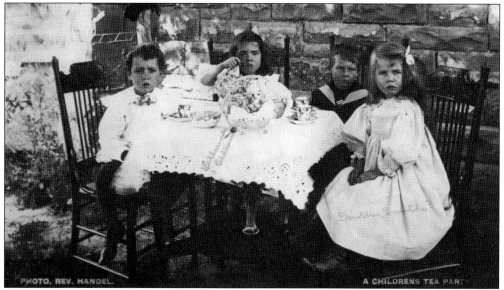

From left to right, Hartley Oldland, Katherine Oldland, Lawrence Smith, and Dorothy Smith hold an elegant tea party outdoors.

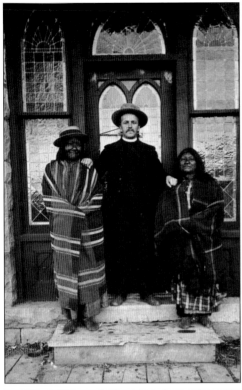

Reverend Handel is seen here posing with two Ute women. Handel titled this photograph "My Friends." The women have their hair cut shoulder length, as was typical at this time; Ute men wore their hair long and in braids. The women have blankets or shawls wrapped around themselves, also typical of Ute women's styles; Ute women still wrap shawls around themselves when participating in traditional activities, such as the Bear Dance.

This 1901 Handel photograph of a group of Uncompaghre Ute was titled "Under Arrest." Chief Eggleston (second from the right) was arrested in Rio Blanco County by game warden George B. Farvert and was taken into Garfield County to be tried for having deer hides in his possession. Prominent citizens of Meeker hired an attorney for Eggleston so he would be well represented. Before the trial even began, the attorney raised the issue that the defendant could not be tried in Garfield County for an offense committed in Rio Blanco County; the case was promptly dismissed and Eggleston was set free with his belongings.

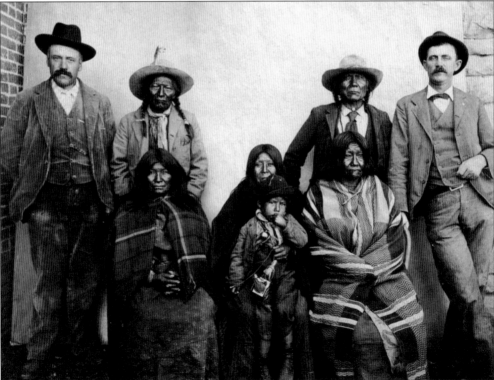

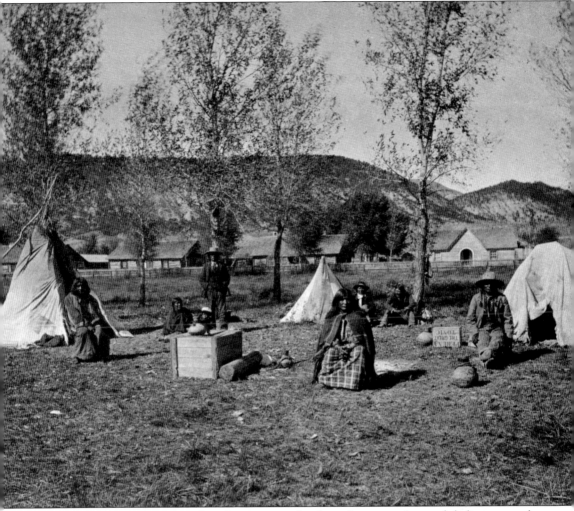

Here, a group of Ute are camped in the county park, where they erected several shelters covered with cloth. Ute living in this area prior to settlement covered their shelters, now known as wickiups, with brush and branches from trees as they were not permanent, but for temporary use. The crate reads "Peruna: the Great Tonic." Peruna was a patent medicine that became a well-known Prohibition tonic, as it was about 18 percent grain alcohol. Most patent medicines that actually produced any effect on the body did so due to their containing opium, cocaine, or alcohol.

This very interesting picture of Edwin Britton was taken by his father, George Britton, who had it on display in the window of his photography studio downtown on Sixth Street in the early 1900s. It was also used in a calendar by the J.W. Hugus and Company store.

Simple yet amazing photographs were taken by early citizens of this area. This one from the early 1900s shows Laura Pattison at Fawn Creek feeding hummingbirds. It seems to show that she is petting these amazingly fast creatures on the head.

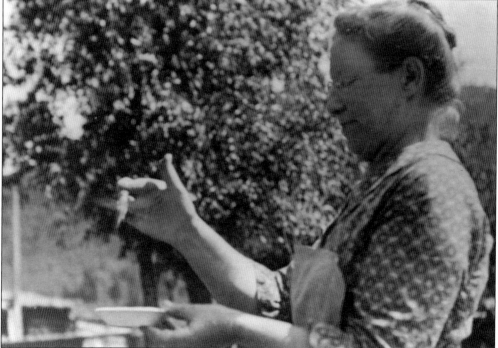

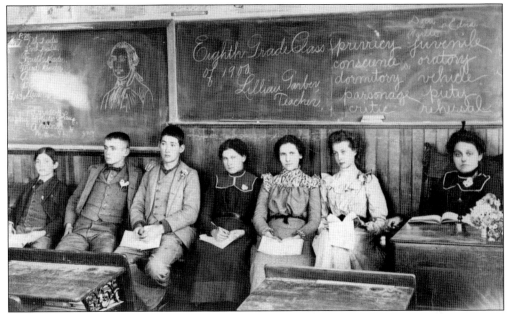

This is a classroom photograph of the eighth grade class of 1900, with Lillian Garber as the teacher. The list of words the children were working on, written on the blackboard, are privacy, conscience, dormitory, parsonage, critic, juvenile, oratory, vehicle, piety, and rehearsal.

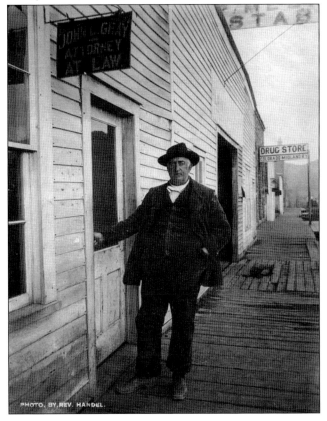

Here is a c. 1900 photograph of downtown Meeker; the office of John L. Gray Attorney at Law is visible in the foreground while behind it is Meeker Stables and a drug store. At this time, Meeker had one drugstore, two doctors, several saloons, livery barns, and hotels. The Episcopal and Methodist churches existed, and collections were being taken to raise funds to build a Catholic church.

In January 1901, Theodore Roosevelt (then the vice president–elect) came for a hunting vacation in a break between being governor of New York and service as the nation's vice president. He came to hunt mountain lions and stayed for three weeks in Coyote Basin. During those three weeks, he killed 17 mountain lions and "a good many bobcats," as the *Meeker Herald* put it.

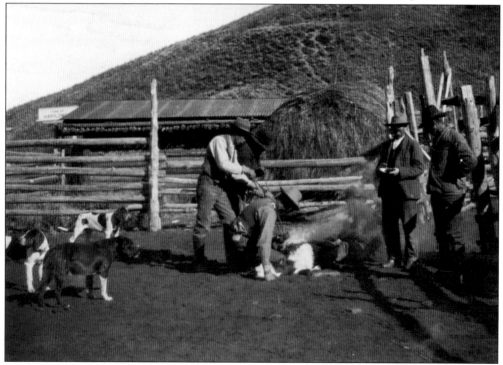

Cattle branding has always been necessary to differentiate livestock. In this local branding scene, Teddy Roosevelt is on the right watching the activities.

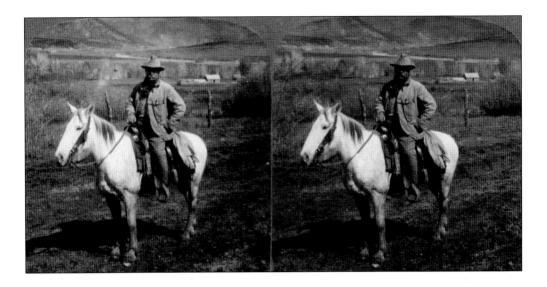

These are stereoscopic cards of Teddy Roosevelt in the area, on horseback and with hunting guides and dogs. Stereoscopic cards present two offset images separately to the left and right eye. These two-dimensional images are looked at through a hand-held viewer and then combined in the brain to give the perception of three-dimensional depth, quite a big deal at the time. It was invented in 1844 and was widely popular by the turn of the 20th century. The first 3-D movie released to the pubic was in 1922.

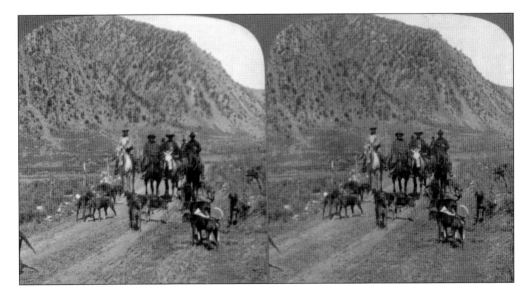

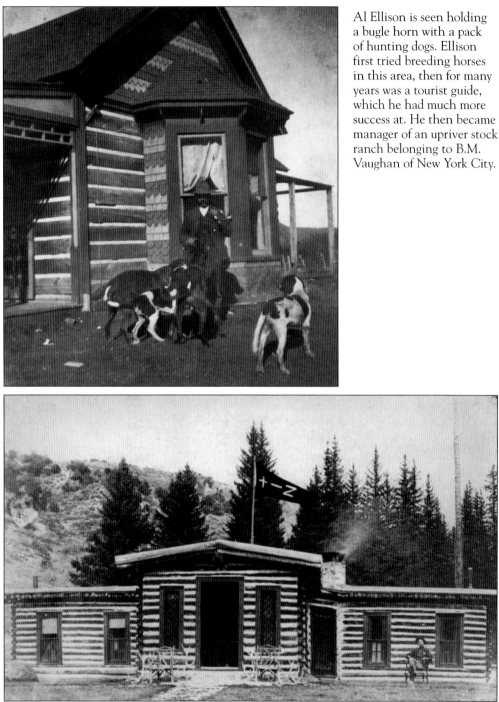

Al Ellison is seen holding a bugle horn with a pack of hunting dogs. Ellison first tried breeding horses in this area, then for many years was a tourist guide, which he had much more success at. He then became manager of an upriver stock ranch belonging to B.M. Vaughan of New York City.

The B.M. Vaughan Lodge, named after its owner, eccentric millionaire Benjamin Masden Vaughan, was located 20 miles east of Meeker on North Elk Creek and was comprised of 960 acres. Vaughan had a lodge building built for himself and his wife and a guest building for the servants he traveled with and for visitors to stay in. Vaughan believed spirits lived in the lodge, and when his wife died, he thought she haunted the building.

This photograph shows Vaughn on the far left, Ellison second from the right, and unidentified others posing outside the guest building in real old west style. Vaughan was the first of the millionaires to stumble upon the area who decided to make it their home away from home.

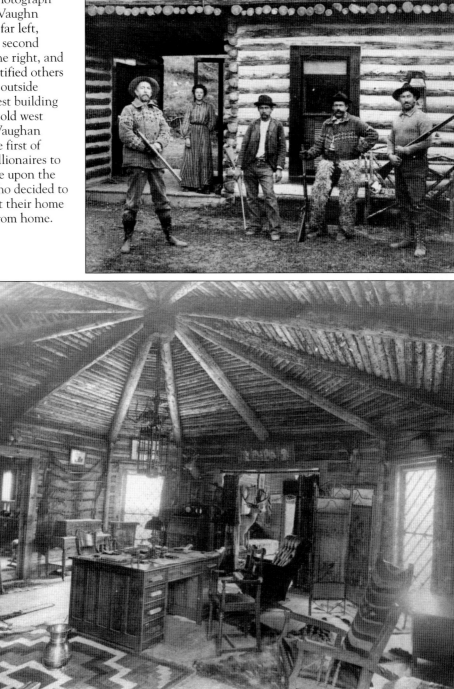

Vaughan did not want people to bother the spirits in the lodge, so when he died it was dismantled; the logs and other things were sold to local ranchers. This unique aspen spider-web ceiling inside the lodge makes one wish the building had not been dismantled so it could still be seen. Ellison used the diamond-shaped windows in his home in Powell Park, as did several others.

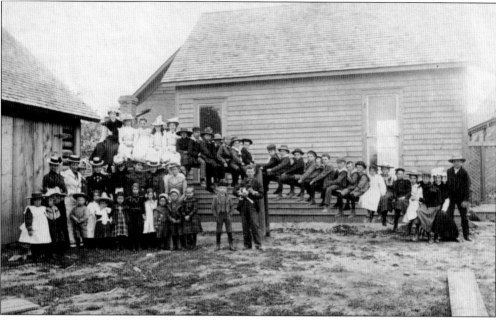

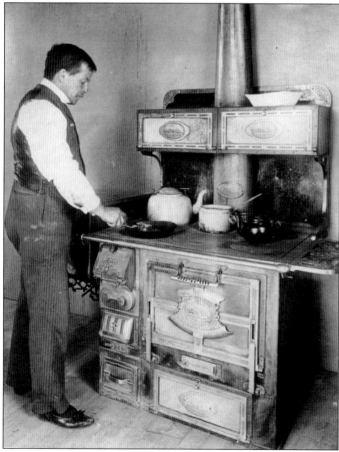

Reverend Handell constructed this enormous teeter-totter, seen here with 27 children on it, for kids to play on in the rectory yard of the Episcopal church. Handell also constructed the rectory and did the smaller tasks at the church himself, from ringing the bells to the cooking and cleaning.

Shown here is the reverend cooking his meal at a Majestic range. The Majestic Company of St. Louis, Missouri, was famous for its line of both commercial and home cooking stoves. At the 1904 World's Fair in St. Louis, the exhibition of Majestic stoves was one of the more popular attractions. Imagine the effort it would have taken to transport this range; it does not look lightweight.

The reverend titled this photograph he took of members of his Episcopal church flock "Even the Older Ones Enjoy It." The ladies do not look as though they are enjoying it, but in general people did not smile for photographs at this time.

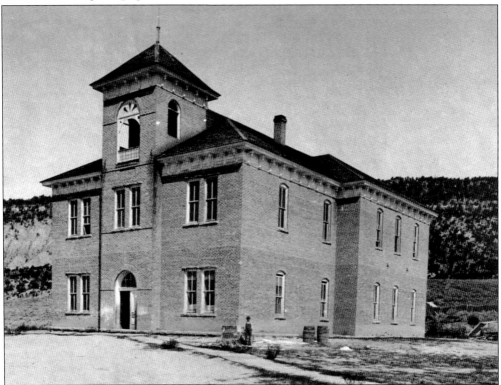

This photograph is of Meeker's first brick school building, which was built around 1890. All grades went to school here until 1906, when, due to lack of space, the high school grades were moved to the IOOF hall and the county courthouse. This situation lasted until the new high school was built in 1911. This building was condemned and torn down in 1918.

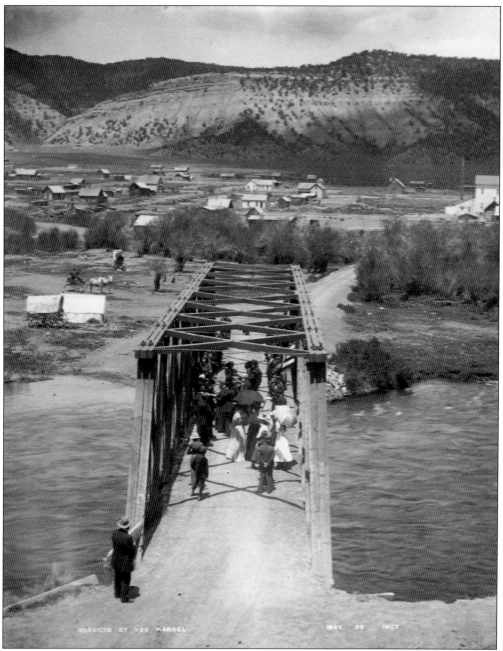

Shown here by photographer H.W. Samuels are Decoration Day services in Meeker on May 30, 1902. Services by Reverend Handell are being conducted on the bridge over the river, with Meeker visible in the background. Decoration Day is what Memorial Day was first called when it was originally created to honor those who died in the Civil War.

Methodist services in the area were originally held in the Powel Park Schoolhouse. The first resident minister was Rev. J. Blaney, who arrived on March 11, 1893. The church was formally organized June 12, 1893, but services were held in various locations around town until the present Methodist church building was constructed in 1899. In 1931, an annex was added on to the north half of the building.

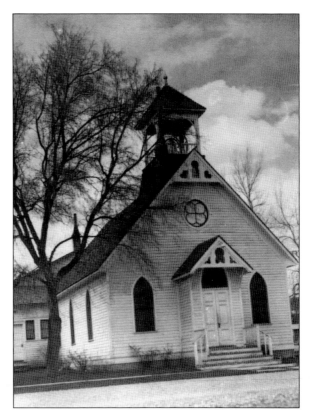

From left to right, Kenneth Sanderson, Douglas Sanderson, and Cuthbert Sanderson are fooling for the camera in this photograph by C.A. Booth. This was given to Kenneth and Douglas's teacher, Charity Ann Brown, as a Christmas present in 1905. Brown taught first grade in Meeker from the fall of 1903 to the spring of 1906.

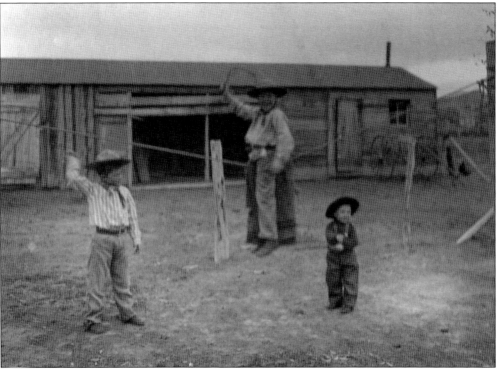

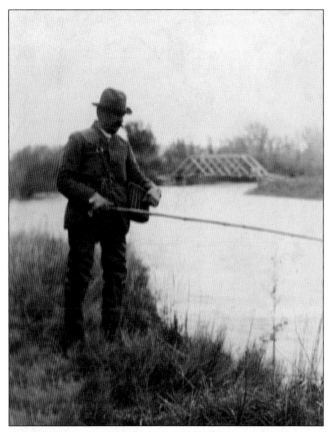

Many photographs exist of avid fisherman Dr. William Brunner; he is seen here fishing on the White River. Dr. Brunner was one of Meeker's first doctors, and his office was in the same building as the Meeker Hotel.

Thomas B., better known as T.B. Scott, is here seen at work in Meeker's first real estate office. During this time, most people did not have just one occupation, but several. Scott ran a grocery store, was the county clerk and recorder, postmaster, a trustee of the Union Oil Company, worked in real estate, was a leader of the Republican party, a charter member of the Rio Blanco Commercial Club, and organized a company that built a carbon black plant in the oil field.

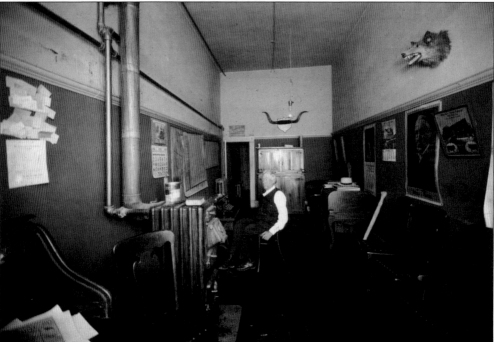

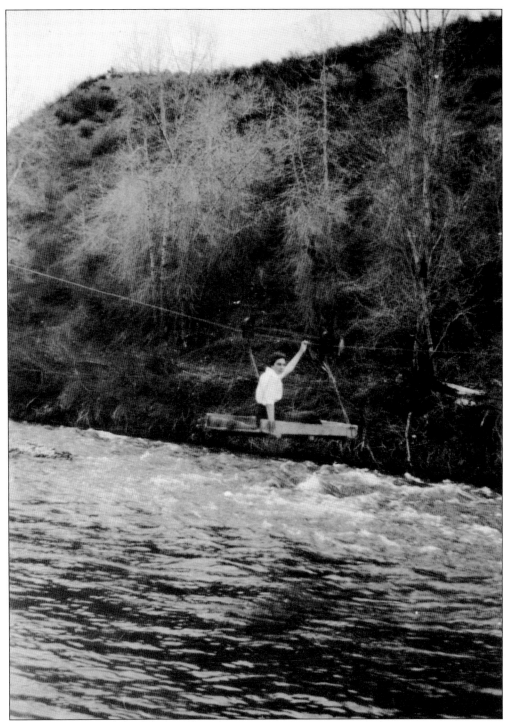

Marguerite Harp is crossing the White River by trolley in this photograph. This setup, which was at the end of Sixth Street, enabled one to pull themselves and a small load across the river by hand. A bridge was not built crossing the river near here until 1940, when one was constructed at the end of Fifth Street.

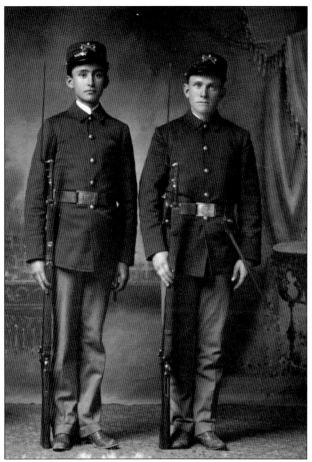

Early Meeker residents Fred Nichols (left) and Fred Riley are in uniform in this 1900 studio portrait. Fred Nichols came to Meeker in 1884 and Fred Riley came to Meeker a year later in 1885.

This c. 1900 photograph shows men playing a game of baseball in the county park, where the courthouse is today. Many activities were held in this park, from America's favorite pastime to picnics. The Ute would camp in this park when they traveled through the area. In this photograph, the old Army officers' quarters in the background can be seen.

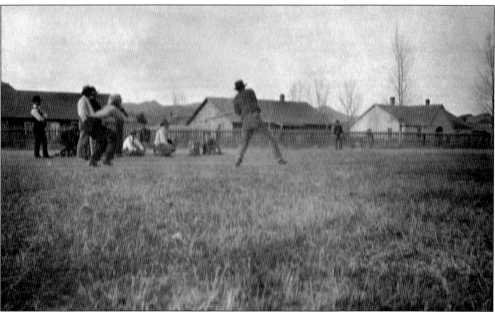

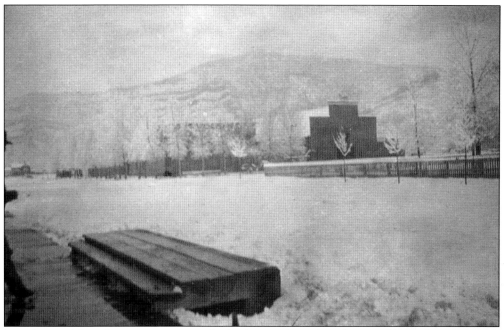

Seen here is Main Street in winter; in the background are the saloon and livery barn on Sixth and Main Streets prior to the 1904 fire that burned them down. In the foreground are wood steps put outside of a Main Street business so customers could step out of stagecoaches and onto the sidewalk, not into snow or mud.

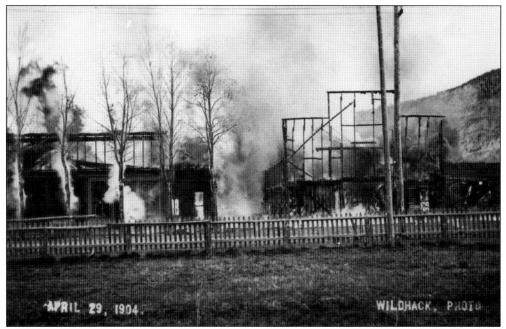

APRIL 29, 1904. WILDHACK, PHOTO

This unique photograph was taken by Henry A. Wildhack in 1904 during the fire that burned down Welch's Saloon and the Hay and Walbridge Livery Barn. Fires were commonplace during the late 1800s and early 1900s, as it was a time of exponential development with a lack of modern building codes, and it was not unusual for businesses to be lost to fire.

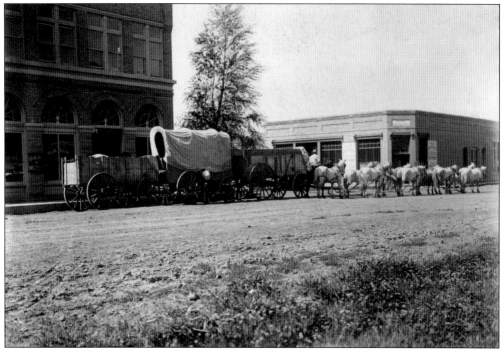

Above is a freight stagecoach in Meeker; all items brought into Meeker had to come by stage. Below is a freight stagecoach leaving town north of Meeker. Simp Harp, as partner with his brother, who lived in Rifle, ran the Harp Stage Line that operated between Rifle and Steamboat, with stops at Meeker and Craig in between. Ed Fairfield and Hiram Perry Spurlock both also ran stage lines that operated out of Meeker.

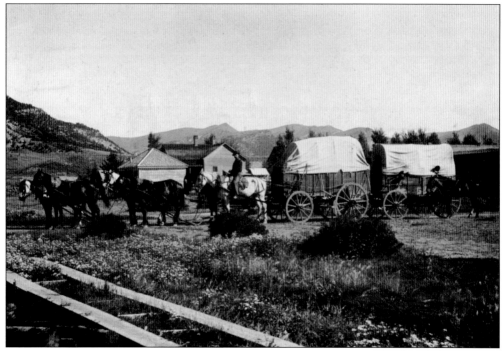

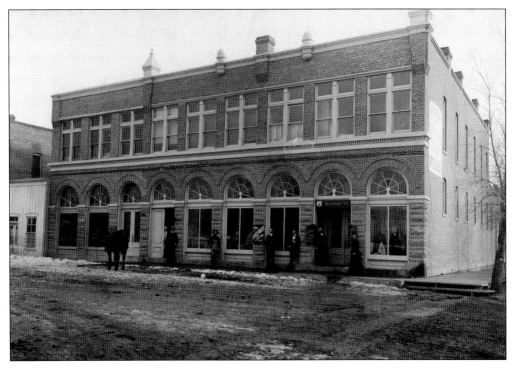

Above is the J.W. Hugus building with its addition, before the fire that burned it down; below is the Hugus building as it was rebuilt after the fire. One big change in this scene is having electric light posts on the street corner. The current building was placed on the State Register of Historic Places in 1991.

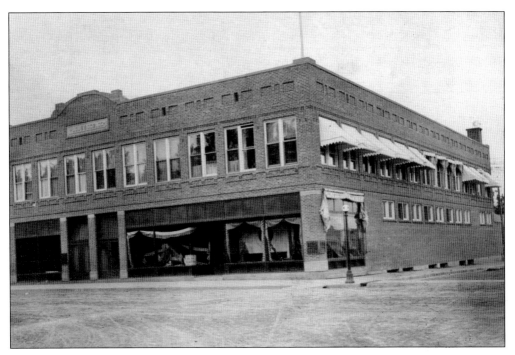

This photograph of the old lumberyard on Water Street was taken on December 5, 1913. Lumberyard owner David Smith can be seen standing in front of the building with Charlie Thompson and Thompson's son Chesley.

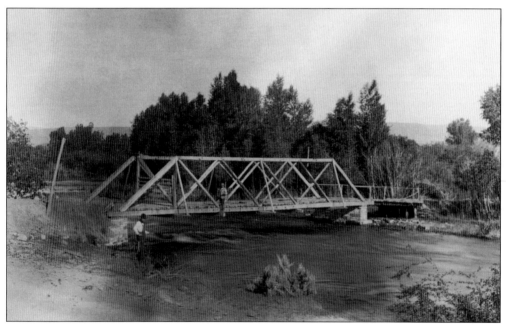

This 1903 photograph shows E.A. Martin and M. Hertz fishing in the White River. The bridge was identified as the T.J. Bridge, a log truss bridge that spanned the river approximately three miles east of town.

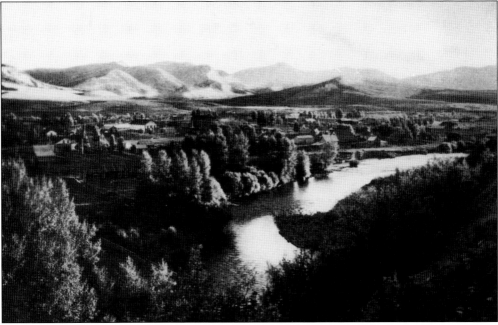

This idyllic scene of the White River with the town in the background was captured in 1908.

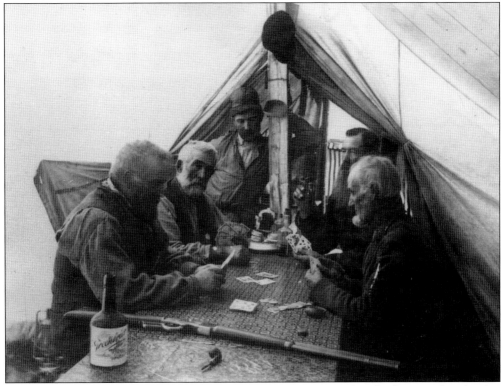

A card game is being played by a hunting party at the Love ranch. Charles Love bought this Piceance Creek ranch from Herman Richner, who had originally homesteaded it, and moved there from Colorado Springs in 1910.

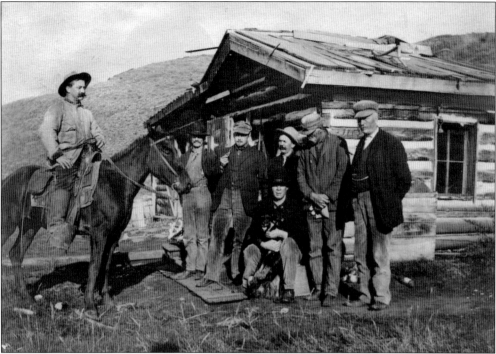

Al Ellison, on horseback, is seen here in 1901 with, standing from left to right, Fred Smith, Ed Arnold, Johnny Smith, Joe Peltier, and Paul Barnhart. Sitting holding the dog is Burnaham Smith. They are at what later became known as the Peltier residence, located one mile west of Buford on South Fork.

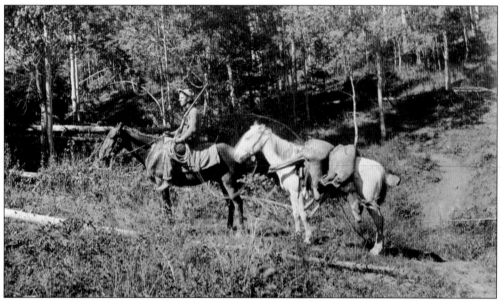

Here is a packhorse bringing a deer out near Marvine lodge during open season. By the turn of the 20th century, hunting was becoming tied to the economy of the area. This became a regional hunting center, and people traveled from all over the United States to hunt in Meeker. Today, the area still maintains large deer populations and the largest elk herd in the United States.

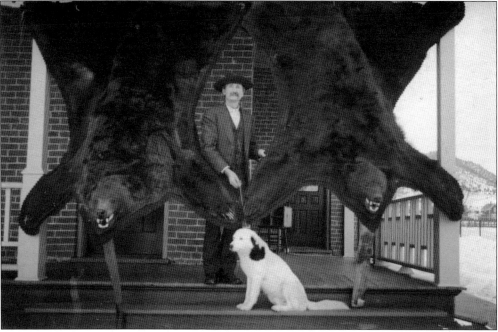

This postcard made from a photograph depicts James J. Donelly, Bruce the dog, and two bear skin rugs in 1909. Donelly was an early taxidermist in Meeker and lived at 917 Park Avenue. Bruce treed the bears; the bear on the right was identified as being killed by John Lough.

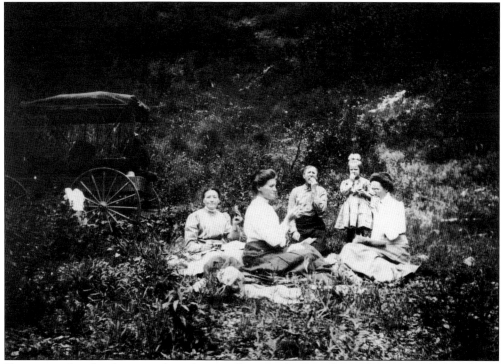

Here is another family picnic shot, this one showing the Donellys and Currys with their friend Mrs. Shawkey in the early 1900s.

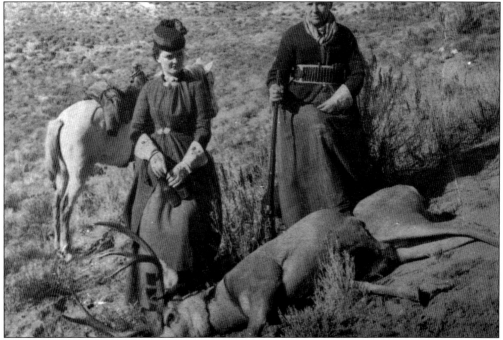

Augusta Wallihan (right), wearing a cartridge belt, and an unidentified person with beaded deerskin gloves and binoculars are pictured here in 1904. Augusta and her husband, A.G. Wallihan, of Lay, were avid big game hunters and wildlife photographers. Their 1901 compilation of northwestern Colorado photographs, *Camera Shots at Big Game*, featured an introduction by Teddy Roosevelt and incredible shots of mountain lions in the Piceance Basin.

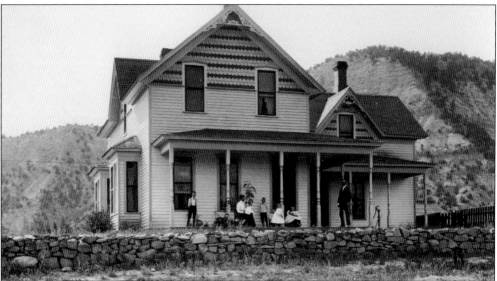

Shown here is the residence of David Smith and family. The family members are (in no particular order) Mary Eliza Allsebrook Smith, David William Smith, Lawrence Smith, Dorothy Smith, Alan Smith, Hilary Smith, and Colin Smith. David was born in Scotland and Mary was born in England; all their children were born in Colorado. After this photograph was taken, the family had two more children, Maria and Latecia. (Courtesy of the Museum of Northwest Colorado.)

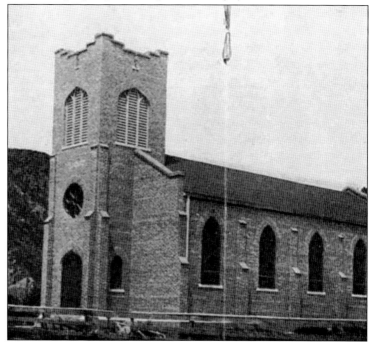

A 1906 capitol stock certificate for 2,000 shares of the New Union Oil and Gas Company is shown here. This company was a reorganization that year of the Union Oil Company, which was formed a couple years prior by Meeker townspeople speculating in the Rangely area.

This redbrick building is the Holy Family Catholic Church, the third church to be constructed in Meeker, on the corner of Ninth Street and Park Avenue. A Catholic priest once joked to the author that so many churches are located on Park that it could be renamed "Church Street."

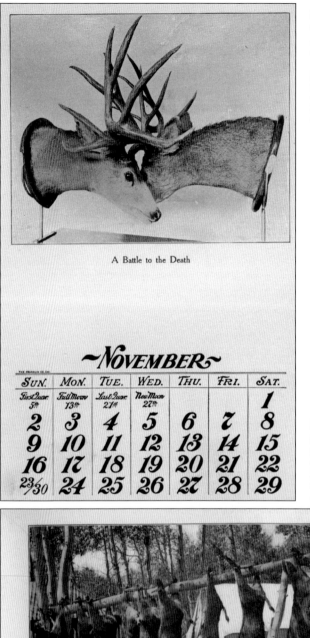

A Battle to the Death

Shown here is a local calendar with November's picture being two deer with locked antlers. The locked antlers mount was given as a gift to Teddy Roosevelt and is now at the Smithsonian Institution. (Courtesy of the Museum of Northwest Colorado.)

September's picture of nine deer strung up on an aspen cross beam is labeled "Camp near Marvine Lodge during the open season for Deer." (Courtesy of the Museum of Northwest Colorado.)

~NOVEMBER~

THE FRANKLIN CO. CHI.

SUN.	MON.	TUE.	WED.	THU.	FRI.	SAT.
First Quar. 5th	Full Moon 13th	Last Quar. 21st	New Moon 27th			1
2	3	4	5	6	7	8
9	10	11	12	13	14	15
16	17	18	19	20	21	22
23/30	24	25	26	27	28	29

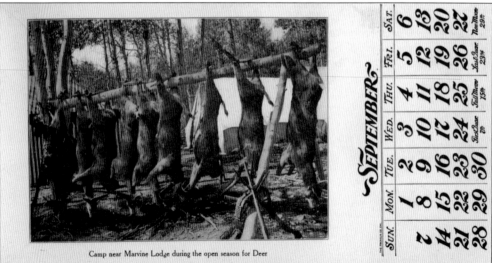

Camp near Marvine Lodge during the open season for Deer

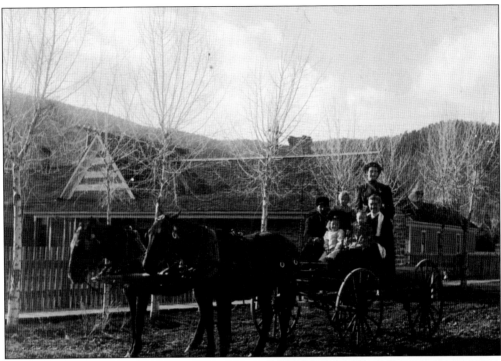

This group riding through town consists of A.J. Denton and his mother, along with Amanda Clure, Opal Skaggs, Dick Skaggs, and Roy Clure in 1911.

This classic old-timer is John Mobley, Fred Mobley's father. He moved his family from Marble to the Blue Mountain area when he felt Marble was becoming too civilized. His son Fred described his childhood as growing up with wild beasts and Indians, becoming fluent in the Ute dialect. Their relations still live in Meeker and Rangely.

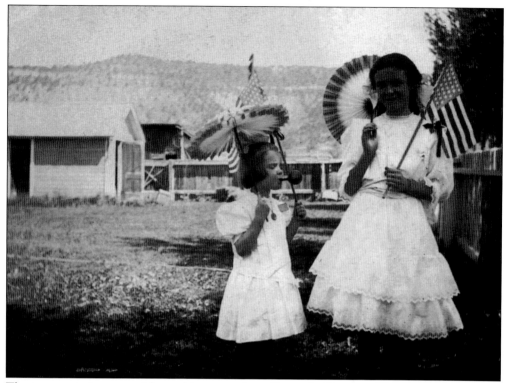

The two patriotic young girls on this postcard are Consuelo Curry and Jennie Brown. Jennie's family remained in Meeker and she was a schoolteacher here as an adult.

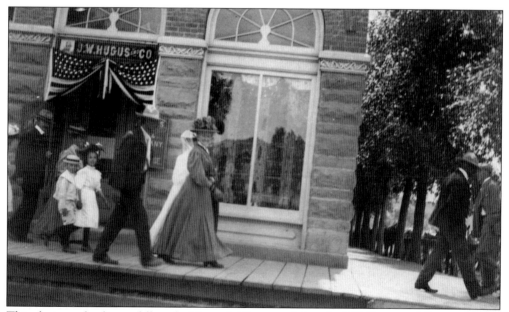

This photograph of townsfolk at the Memorial Day parade has the J.W. Hugus and Company store in the background. The image had to have been taken before 1911, when the store burned.

These photographs could be titled "Having Fun in the Piceance." Sisters Sadie Allen Dickenson and Ollie Allen Duckett are dressed up as tough guys and the guys are pretending—not too hard—to be ladies in these funny pictures.

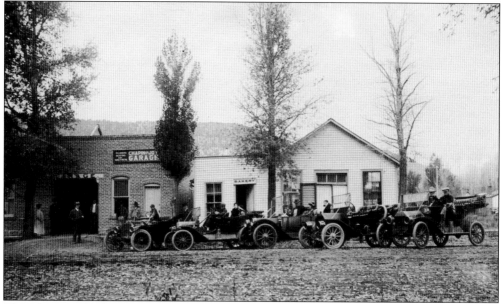

This photograph shows the Chapin and Joy Garage, on the north side of Main and Seventh Streets, in 1910. The garage was later used as Bruce Motor Co. The little frame building was used by Ada Joy as a bakery; the house adjoining it was the Joy residence.

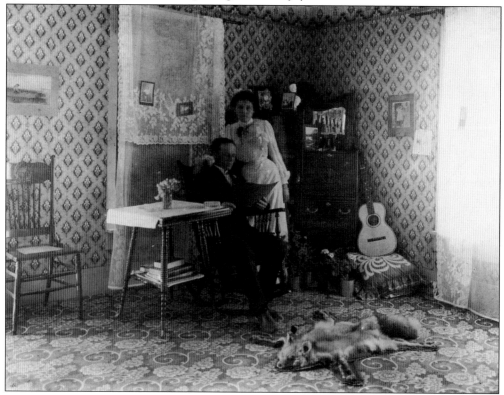

Here is a time capsule of what a young married couple's house looked like in the early 1900s. Lillian and William Purdy were married in 1902; the front room of their house is seen here.

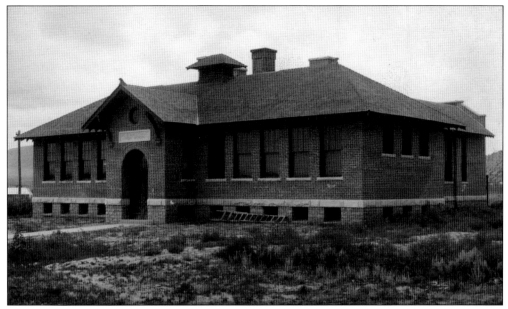

This was the first Rio Blanco County High School, which was built in 1911. This school started Meeker's long history of issues with school building construction, the high school lasting only eight years before being condemned. Other schools built after this one were condemned and repaired multiple times. This was the only high school in the county during its time, and out-of-town students would have to move to Meeker to attend, having to pay or work for room and board with a local family.

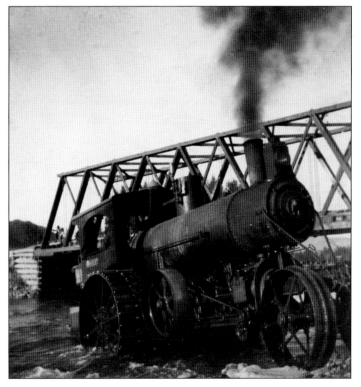

The White River periodically overflows its banks, threatening structures built near it. Here, the first steam engine in Meeker saves the day by dredging out debris that clogged the river and caused a flood. The engine was an Avery under-mounted double-cylinder steam traction engine that was designed for heavy traction work, the company's slogan being "better and cheaper than horse power."

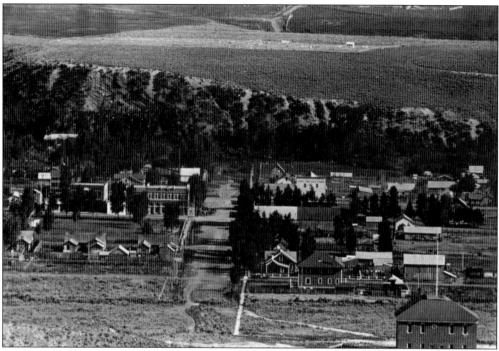

This c. 1900 Meeker overview was taken from the hill above Sixth Street, with Highland Cemetery visible on the hill overlooking the town. The first cemetery in Meeker was located where the hospital now stands. The bodies were thought to have all been relocated when Highland was established; however, when ground was broken in 1950 for Pioneer's construction, an unintentional discovery proved otherwise.

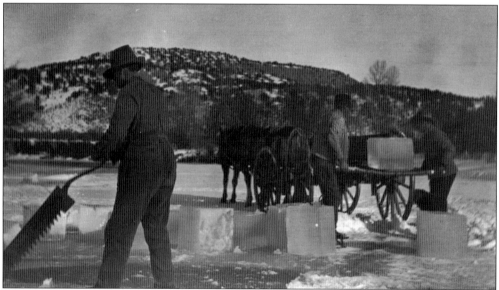

Ice was traditionally cut out of the river the second Monday in February each year. Three-by-three-foot blocks were cut out with saws and then pulled up into a truck by a pulley system and ramps. The ice blocks would be taken for storage, where they were packed in sawdust and covered to be used through the summer.

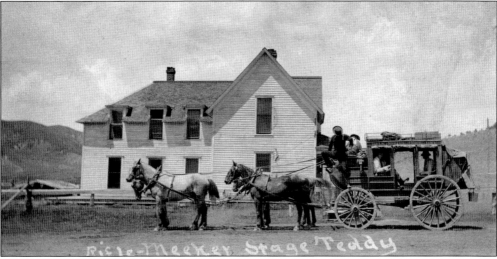

This was the halfway station for overnight stops and meals for travelers on the Rifle-to-Meeker route. The big white frame house built by J.A. Alley had 14 bedrooms, offices, a waiting room, a dining room, a private living room, private bedroom, and storage room. The stagecoach was owned by Hiram Perry Spurlock, who had three coaches, each named after one of his children—Teddy, Ella, and Mary. The coach pictured here was Teddy.

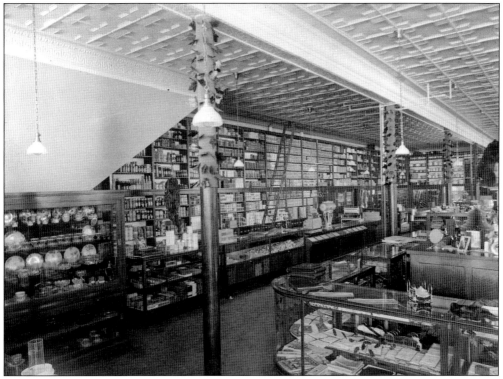

This is the inside of the J.W. Hugus and Company General Merchandise Store as it appeared in June 1911. Hugus were purveyors of everything from china, cookware, and canned goods to axes and handkerchiefs. Decorating the store are fall leaves affixed to the pillars and display cases, as well as a taxidermy bear.

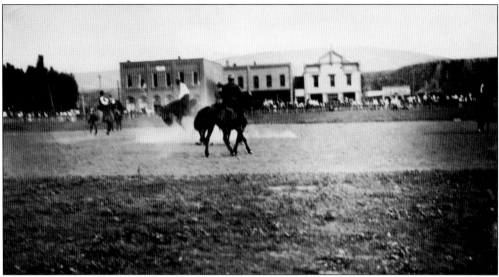

Here, a saddle bronc rider and pickup men are participating in a rodeo event on July 4, 1911; the IOOF hall, Park Hotel, and Antlers Hotel are visible in the background.

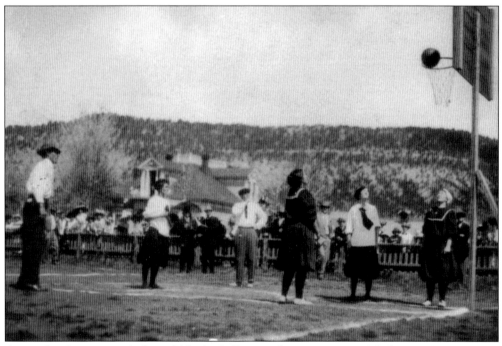

A crowd gathers to watch the girls' basketball team playing a game in Meeker in 1913.

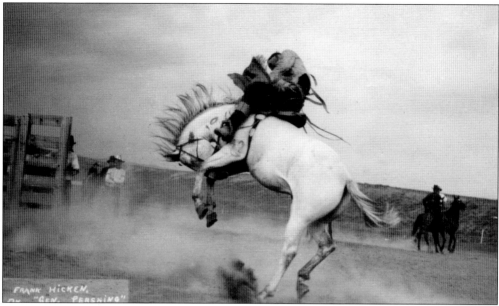

This now classic Meeker rodeo photograph is of Frank Hicken on a horse named General Pershing at the Fourth of July Rodeo. Frank lived and worked on ranches upriver, but rode bucking horses to make money at summer rodeos during his youth.

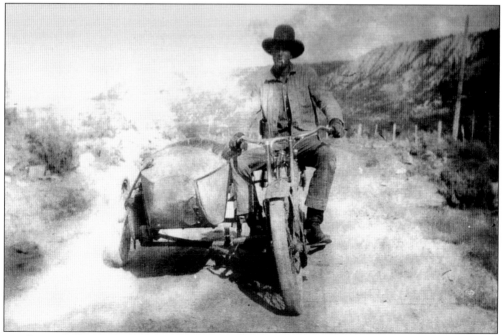

Frank Hicken, 19 years old in this image, is riding down the road on his homemade rodeo rig. He traveled from rodeo to rodeo in the summer on this rig, which consisted of a motorcycle with attached sidecar used to carry his saddle and other gear. (Courtesy of the Dortch family.)

James R. Riland founded the *White River Review*, which published weekly from 1902 to 1934. Riland started working on the *Colorado Springs Gazette* in 1877, later moving on to the *Leadville Herald* and the *Leadville Democrat*. While in Leadville, he was said to have grubstaked prospectors on shares, thus securing a number of mining claims, some good, some not. He avidly collected mineral samples, and his collection was said to be amongst the finest in the state. After a stint in Glenwood Springs, he settled down in Meeker and began the *White River Review*.

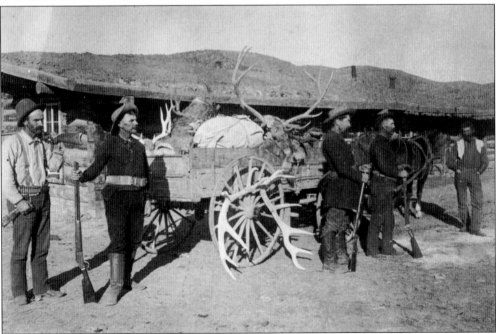

The Frank Musgrave Ranch dwelling house is seen here with hunters and their bounty of hides and antlers.

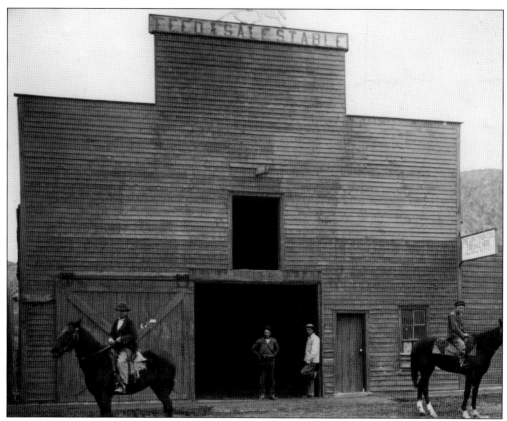

This is the livery stable that was commonly known as the "Red Barn." The sign on the building reads "Lion Canon Coal for Sale Here."

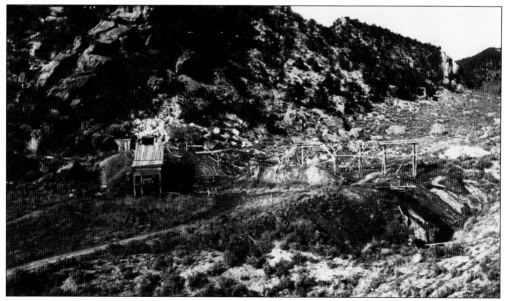

This is a USGS photograph of the Lion Canyon Coal Mine, west of Meeker in 1911. (Courtesy of the United States Geological Survey.)

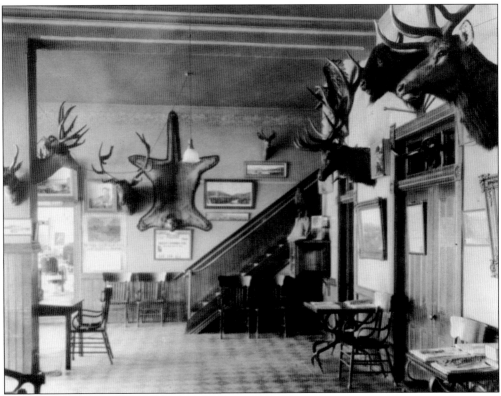

When the Meeker Hotel building was constructed, the rooms were considered very large and modern. It was said to be the grandest hotel in this part of the state, and the locals were extremely proud of it. Here, the lobby, decorated with taxidermy animals that include elk, deer, antelope, bison, and mountain lion, can be seen. At different times, a café and a billiard hall were in the hotel. Below, the transom window sign above the door advertises that there is a barbershop inside the building.

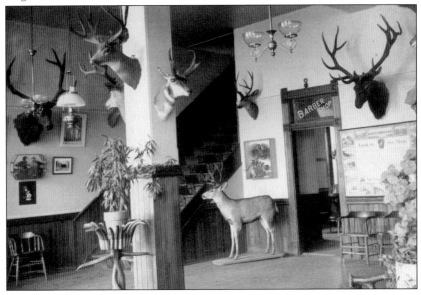

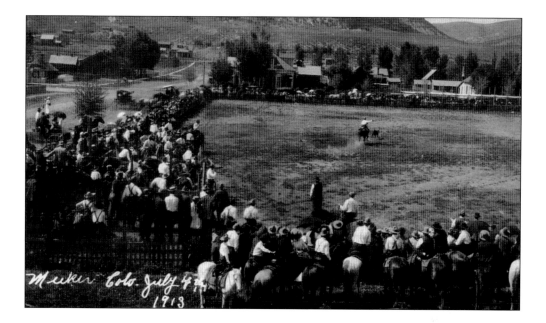

Above is a Fourth of July calf-roping event being held in the town's park, which used to be the old parade grounds from the military camp. Below is another rodeo event, the Potato Race, being held on a town street; the spectators line the street, watching the excitement close-up as riders attempt to drop a potato in a crate.

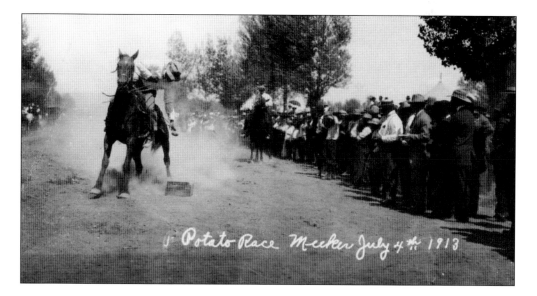

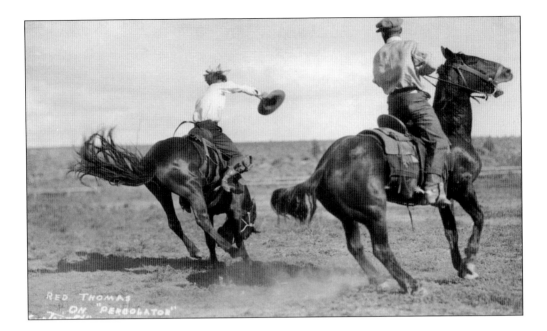

Above, saddle bronc rider Red Thomas looks like he is in a hairy position in this rodeo scene. Below, Red Thomas is atop a rearing horse named Lightening. The photographer caught the movement and the horse's expression so well that it feels like seeing it in person.

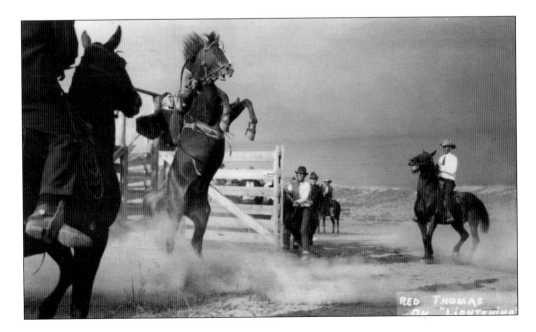

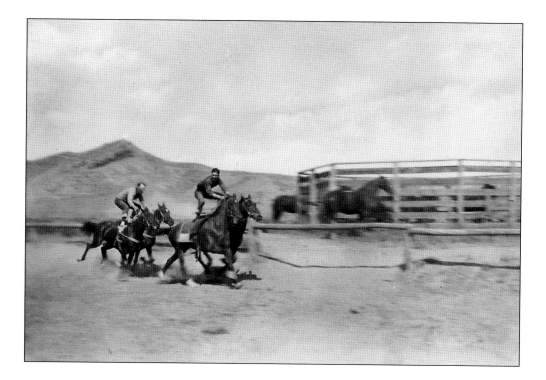

Here, the action of the day is caught perfectly by the photographers documenting the Roman riding and the races at the fairgrounds. Roman riding is one of the oldest forms of trick riding. Trick riding was banned from rodeo competitions in the 1940s due to tricks becoming increasingly dangerous as each person tried to outdo the next, and is now only for entertainment.

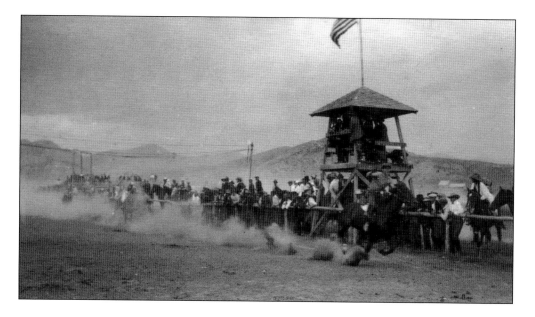

The Budge family ran a summer resort on South Fork prior to there being roads that went all the way up to Trapper Lake. They spent their summers there for 40 years; they would try to come upriver at the start of the summer with all supplies they would need, as they had to come in by horseback. They did not buy a car until 1915. They only came to town twice a year, but mail did come out to them. Here at Budge Resort are, from left to right, Harry Budge, Betty Budge, Irma Rector and sons, Etta Budge, and Ed Budge.

Going to the traveling circus has been a popular activity in American towns since their inception in the early 1900s. This is the first circus to come to Meeker, possibly in the summer of 1910. The big top tent was put up in the town park; Jan Oldland's house is visible in the background.

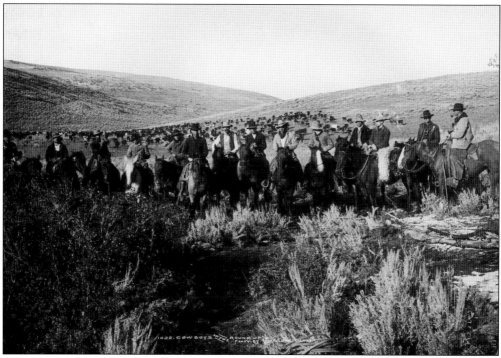

This L.C. McClure photograph, taken in the Piceance, was titled "Cowboys on the Roundup." George Wear is identified as the cowboy in the white chaps. Wear came here in 1900 and worked for large cattle outfits and ranches, owned and operated his own cattle ranch, worked for the forest, did county road work, and took part in the early rodeos. The photograph below is another by L.C. McClure of Denver that was taken in the Piceance; it is titled "A Cowboy Camp."

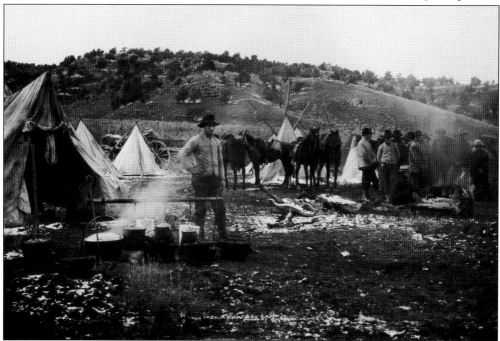

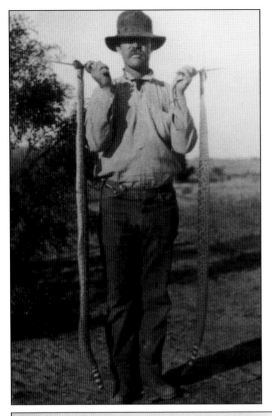

In this great photograph from 1905, Ed Cole holds up a rattlesnake in each hand.

Shown here is a 1914 photograph of an oil rig in the earlier days of development in Colorado, still prior to the Rangely and Wilson Creek fields getting heavily developed. This oil rig was located one mile north of the White River, near Wolf Creek. (Courtesy of the Museum of Northwest Colorado.)

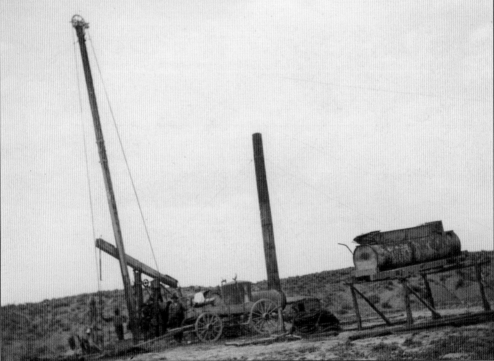

Here is five-year-old Charles E. Brown at Jerry Allen's cabin with his pets: a fawn, a kitten, and a lamb.

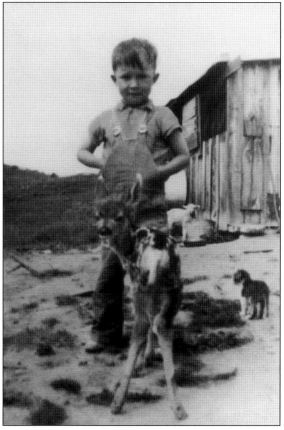

This group photograph by Lena Idol is of the Ladies Aid; it was taken at the Montgomery House by the Rio Theatre in 1916.

Here, J.N. Curry and Ike Allen are pictured in 1909.

Rio Blanco County High School students and classmates of Willie Harker, who died of a ruptured appendix, are identified from left to right as (first row) George Lyttle, Jennie Brown, Elio Harris, and Hilary Smith; (second row) Olive Chapin, Mary Moulton, Mary Davis, Margaret Taylor, Mildred Joy, Marguerite Harp, unidentified, Blanche Bailey, Eva Skinner, Esther Coudrey, Thelma Fairfield, Irene Hay, Freddie Frizzel, Dorothy Carr, Jack Montgomery, Freeman Fairfield, and Noel Chapin. The RBHS school banner they made for the funeral services was made out of sweet peas.

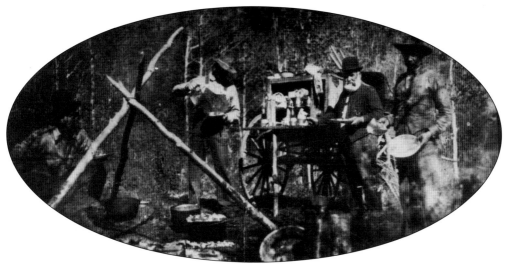

This photograph, taken by William Purdy, is of a telephone repair camp.

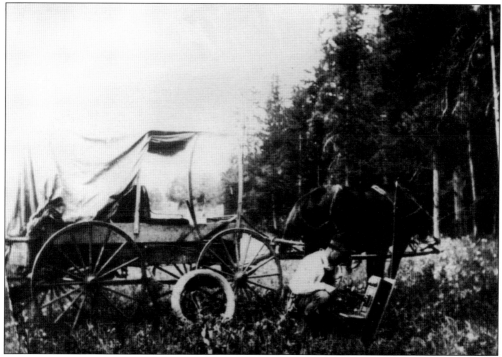

William Purdy, better known as Will, is seen here working on the telephone lines of the early phone system. Purdy was the first manager of the Meeker Telephone Exchange. Their first office was in the Meeker Hotel building, and at this time, there were only 70 telephones in the whole of the White River Valley, including the town.

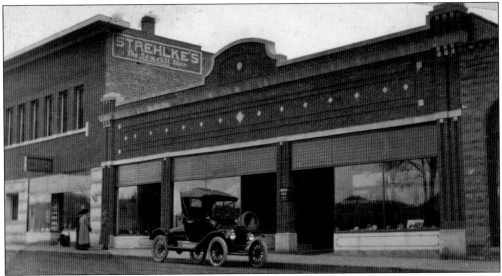

This postcard features an automobile parked outside of Strehlke's drug store in 1915. Before this, Strehlke's was in the native stone building adjacent to this, later moving to the brick building across Sixth Street opposite the J.W. Hugus Building.

These women, outdoors in their sun hats, are Irene Amick, Mary Amick, Eunice Amick, and Anna Kratch, likely in the late 1910s or early 1920s. The hats the women are wearing are cloche hats, which were invented in 1908 and became widely popular by the 1920s.

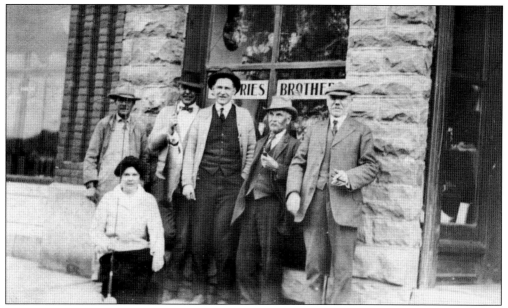

Here, a group of happy fishermen are posing outside a downtown business, likely on their way back from the river.

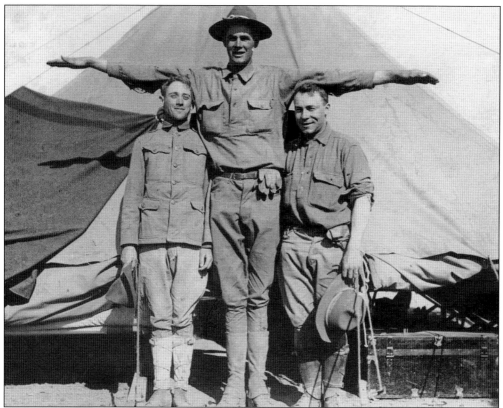

This photograph is of Ralph Hicken and two other (much shorter) World War I servicemen. (Courtesy of the Hicken family.)

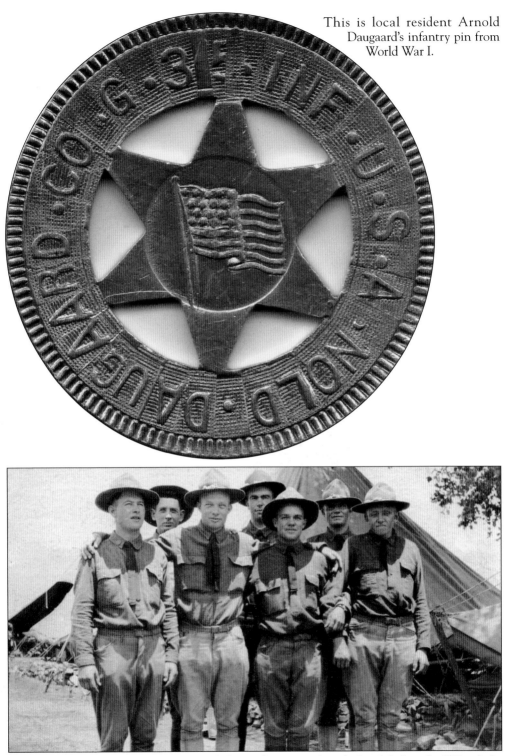

This is local resident Arnold Daugaard's infantry pin from World War I.

These World War I servicemen are, from left to right, Ernest Amick, Roy Mathes, Carl Wunderly, Bert Whitlock, unidentified, Henry LaCamp, and Arnold Daugaard.

Four

1920S AND 1930S

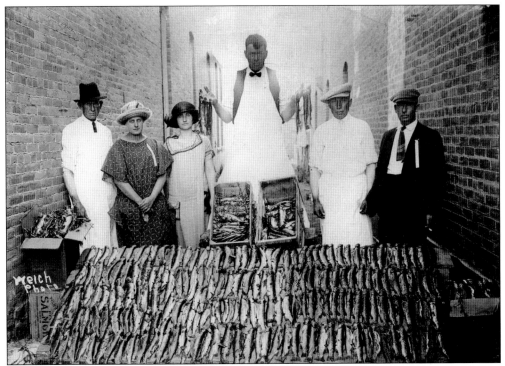

The fifth annual IOOF fish fry was held June 23, 1923, and there was quite a turnout at the county park for the event. In preparation for the huge event, the cooks were keeping the fish cool in the alley between the IOOF hall and the Park Hotel.

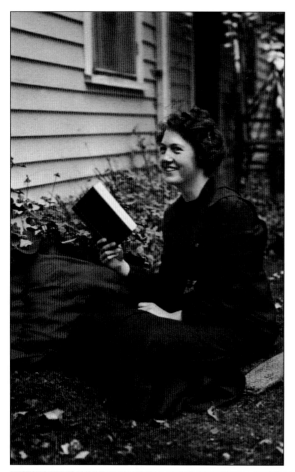

Here, Irene Hay is sitting outside reading a book. Irene was the only daughter of Henry and Cora Hay, early pioneers of Meeker. Henry and his brother, John, moved to Meeker in the spring of 1880.

Ever wonder what the record is? Here, eight children pile on the back of a horse for a photograph outside the Lime Kiln School. (Courtesy of the Moyer family.)

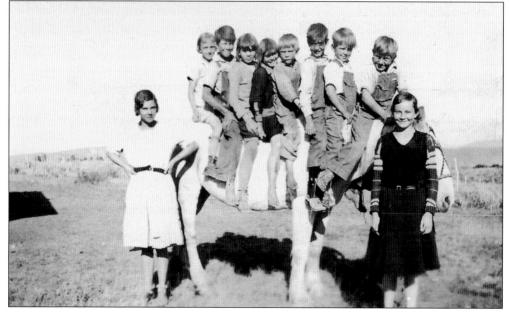

Lloyd Failing, a Craig resident, is posing with the bear he shot at Wilson Creek in 1920. Failing was hunting for deer when he was surprised by coming face-to-face with this black bear. The bear reared on its hind legs and Failing killed the 275-pound animal with one well-placed shot. (Courtesy of the Museum of Northwest Colorado.)

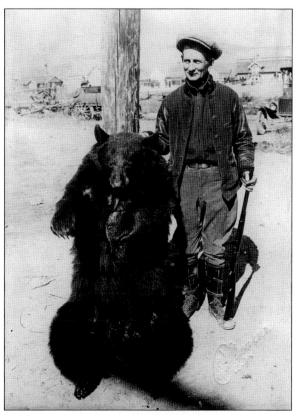

This photograph was taken inside Strehlke's drugstore. Trinkets and chocolates for sale and the presence of a soda fountain indicate that the general public is starting to become more affluent, having money to spend on these types of nonessential items. There are tables where ladies were known to come for ice cream and sodas, and even one small round table for kids.

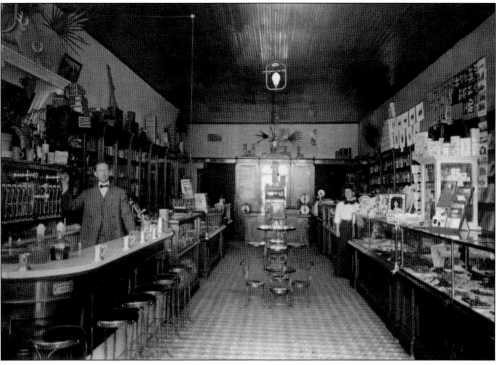

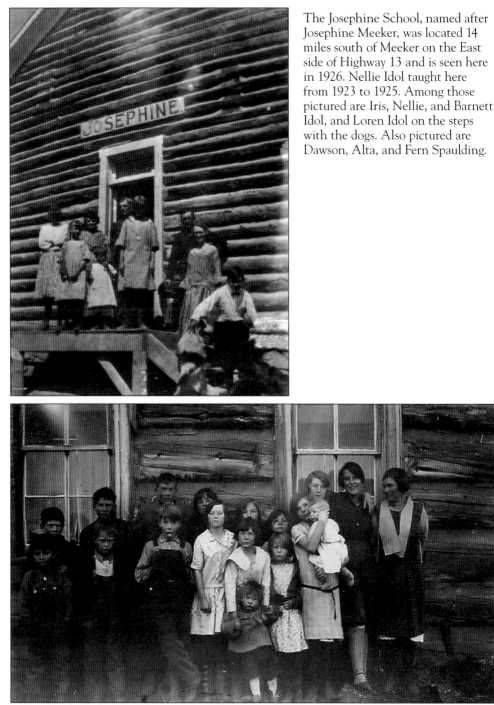

The Josephine School, named after Josephine Meeker, was located 14 miles south of Meeker on the East side of Highway 13 and is seen here in 1926. Nellie Idol taught here from 1923 to 1925. Among those pictured are Iris, Nellie, and Barnett Idol, and Loren Idol on the steps with the dogs. Also pictured are Dawson, Alta, and Fern Spaulding.

This is the Lime Kiln School class of 1929 outside of the schoolhouse; Eleanor Service was their teacher. The oldest students pose with smiles, the rest with serious faces, and one joker sticks out his tongue for the camera. The Lime Kiln School, built on private land owned by the Service family, was the highest historic rural school in Rio Blanco County at over 8,000 feet above sea level. (Courtesy of the Schoenhal family.)

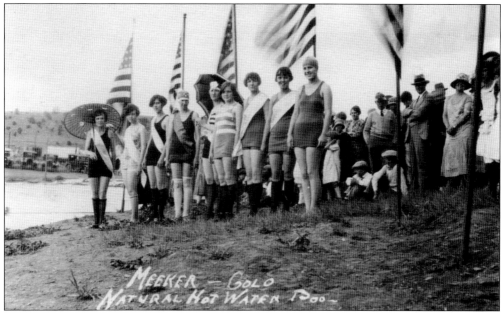

This postcard features the contestants at the natural hot water pool in 1926; these women have affectionately been referred to since as Meeker's "Bathing Beauties." The fourth from the left, Anabella Bartlett, won first prize.

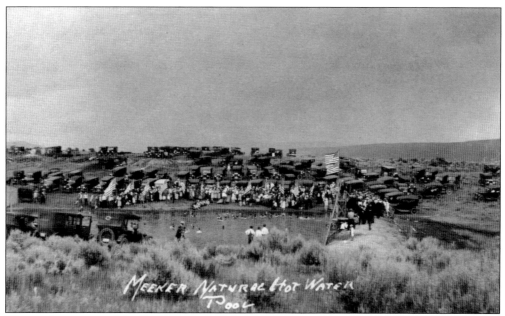

This is the setting of the Bathing Beauties contest, with cars parked all around the pool. The pool was a natural hot water pool on top of Meeker Dome.

Nettie Bainbrich Dudley and her son Harland Dudley are pictured here in the 1930s. The first post office on Piceance Creek was established in August 1892, with Nettie Dudley as postmistress.

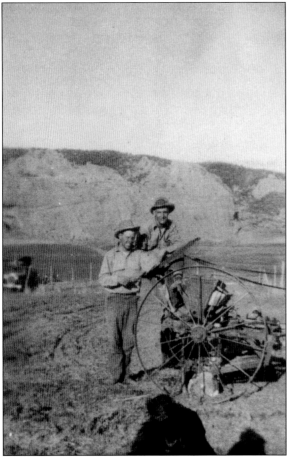

Rob Eller and George Bewley take a break from raking hay. Haying has always been a time-consuming enterprise and remains so to this day, even with modern machinery, as folks try to get it put up before weather threatens. This photograph was taken on the old Eller ranch on Strawberry Creek.

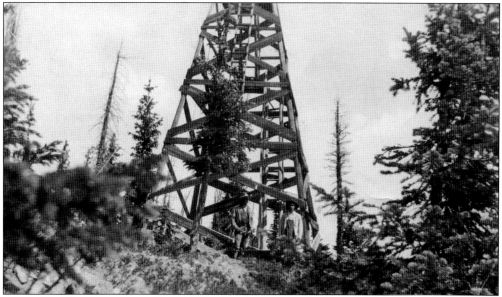

This is the lookout tower above Meeker in the 1910s or 1920s. Leonard Valentine and a friend stand in front of the tower.

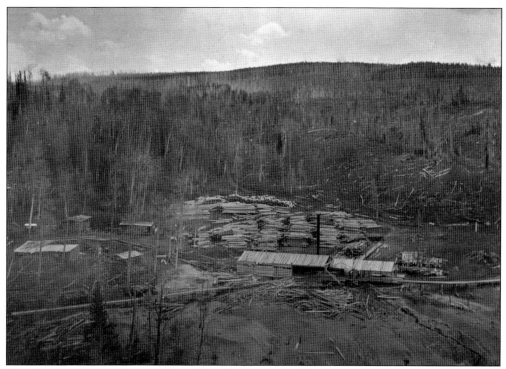

The Sleepy Cat sawmill, owned by T.D. Riley, is pictured here.

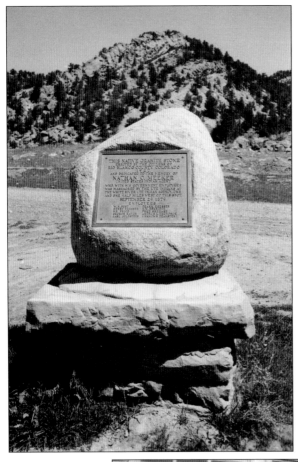

This is the native granite stone and plaque erected by the citizens of Rio Blanco County in 1927, the 50th anniversary of the massacre, and is dedicated to Nathan Meeker and his employees. It was not until many decades later that the Ute side of events started being portrayed, and memorials were placed to honor their dead at the battlefield.

This is the 1928 Rio Blanco County High School basketball team. From left to right are (first row) Donald Tagert, Bob Thomas, coach Leland Glandon holding the trophy, Herb Rector, and Gene Bridges; (second row) Robert Crawford, Ed Miller, and Howard Alfred.

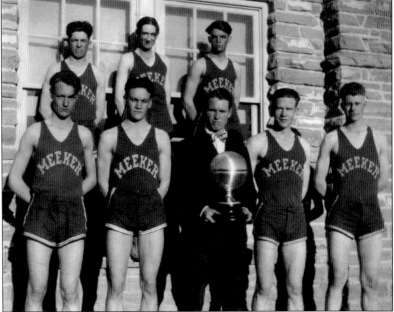

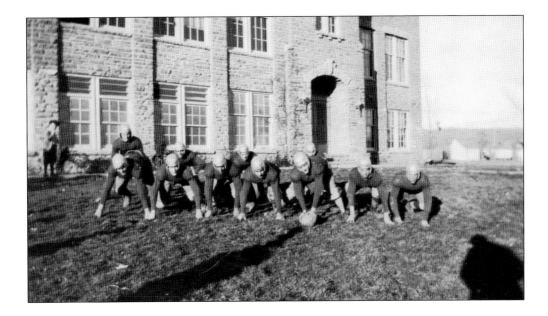

These classic photographs are of coach Leland Glandon's high school football team. He coached football and basketball at the high school in 1926, 1927, and 1928. In the photograph above from 1926, the players are, from left to right, (first row) Gene, Herb, Duke, Don K., Tom M., Dell Powell, and Wayne House; (second row) Don T., Orville, Muck, and Frost.

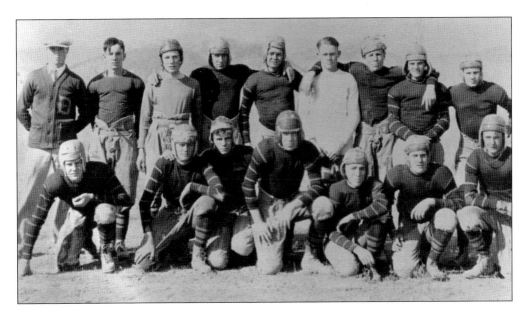

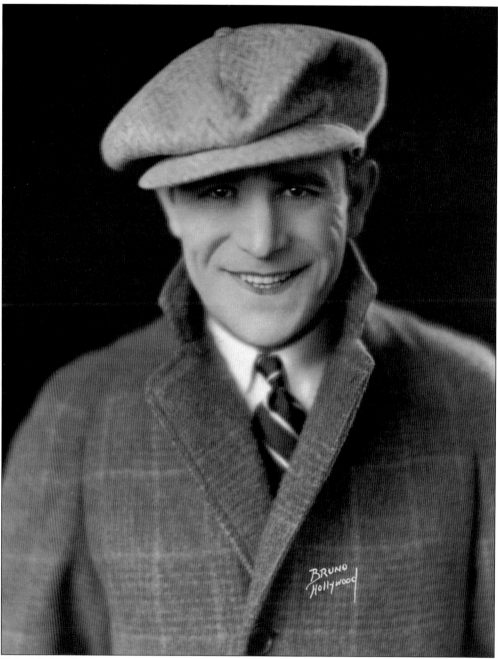

Kenneth Sanderson was born and raised in Meeker, and, like many, was an athlete and a cowboy in his youth. He moved to Hollywood, where he became a film actor and stunt performer, working from Hollywood's early silent films through the 1950s, going by the name of Buddy Roosevelt. During his career, Sanderson worked on many Westerns with John Wayne until he retired in 1962 and returned to Meeker, where he passed away in 1973.

Nellie Reagle, Lou Reagle's wife, is seen here posing next to a 1927 Chevrolet with a shotgun.

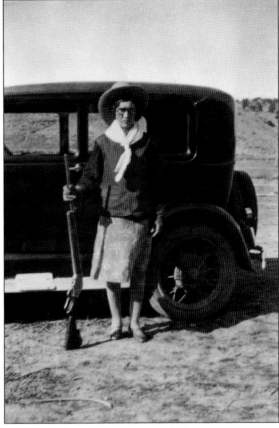

Three pretty young women— Peggy Holton, Renova Holton, and Bernice Eller—pose on a burro for the photographer.

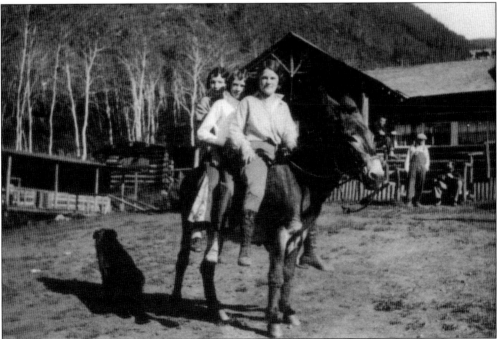

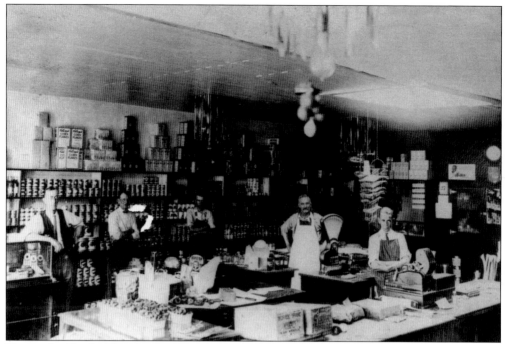

This is the Charlie Thompson grocery store on Main Street between Sixth and Seventh Streets in 1920. Charlie Thompson, the owner, is on the far left, followed by, from left to right, Marion Thompson, Hartzel Thompson, George Suttles, and Chesley Thompson.

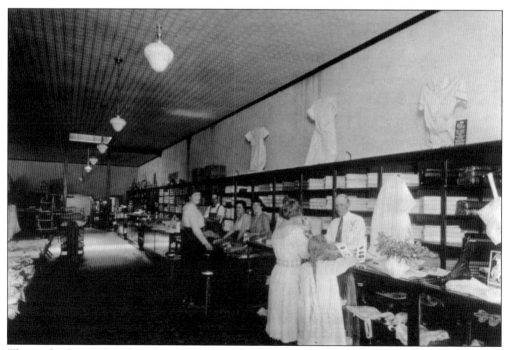

This is the Simms-Moulton Store in 1922. Billy Simms is waiting on a customer.

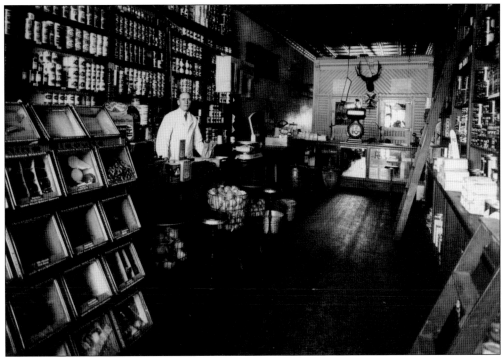

This was the market on Main Street, west of First National Bank, in 1922 or 1923. George E. Aicher and Clyde Stephenson owned this grocery store.

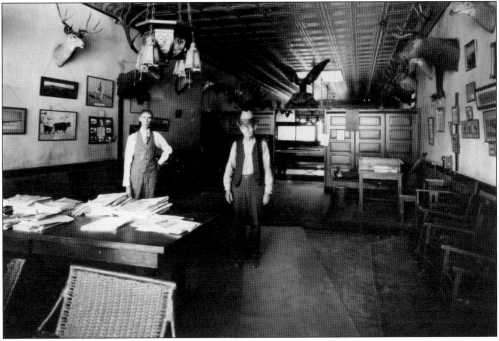

This was the inside of the Commercial Club; E.A. Martin (left) and M. Hertz are pictured. The Commercial Club was started in 1913. Farmers would come to town to do all their purchasing, and then, after the stores closed up, the men would go to the commercial club to play poker.

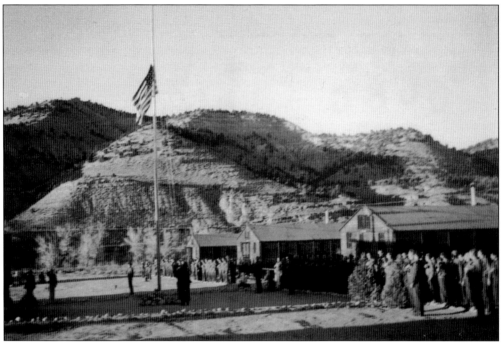

Franklin D. Roosevelt took office in 1933, and in his first 100 days, approved several measures as part of his New Deal, including the Emergency Conservation Work Act (ECW), which would later be officially renamed the Civilian Conservation Corps (CCC) and affectionately referred to as "Roosevelt's Tree Army."

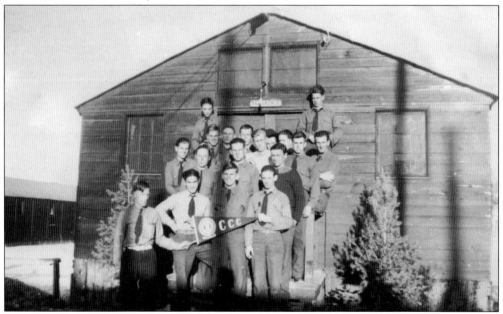

CCC Camp Meeker (Camp G-107), started in 1938, was located 10 miles west of town. The young men from Connecticut operated a grazing camp constructing range improvements such as roads, fencing, stock driveways, erosion control check dams, and reservoirs. It operated for four years, then was briefly vacant until the structures were torn down by the Army in 1943.

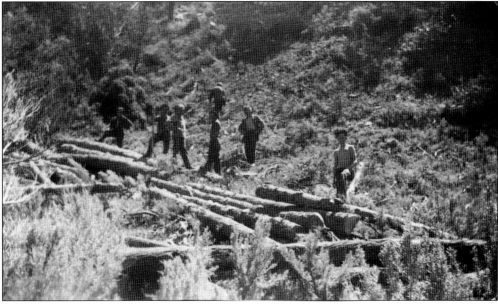

The ECW, or CCC, was Roosevelt's proposal to recruit 500,000 young men to a peacetime army with the aim of simultaneously relieving unemployment while battling erosion and restoring the nation's natural resources in forests, parks, and rangeland through public works. Here, CCC men from Camp Meeker are hard at work felling trees.

Here, some of the CCC Camp Meeker men are getting a well-deserved rest at Happy Landing Swimming Pool, a wooden pool built upriver by Henry Petersen.

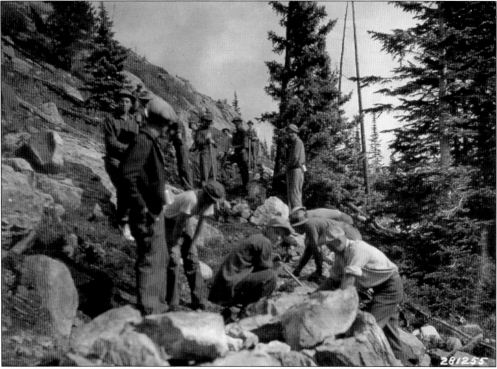

Here, CCC men are building a trail in the White River National Forest. Many of the trails in the forest, as well as ranger stations like Buford and Lost Creek, were constructed by the CCC. (Courtesy of the United States Forest Service.)

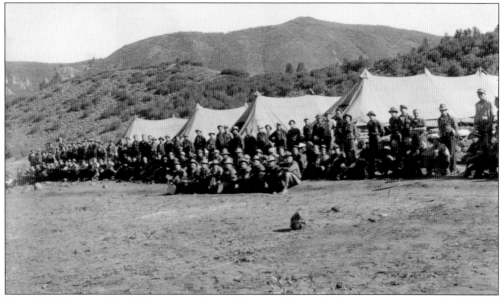

This CCC Camp, officially known as Camp Marvine (Camp F-6), was more commonly referred to as the Ute Creek CCC Camp, as it was actually located on the Ute Creek drainage. This was a 200-man tent camp in the Sleepy Cat District of the White River National Forest. (Courtesy of the United States Forest Service.)

This picture is of Ruth Caldwell in 1936, riding Jack Sprat at the Scenery Gulch Ranch. Jack Sprat was a well-known Morgan stallion in the White River Valley, having sired many colts from ranches in the valley. Ruth describes him as high-spirited but gentle, stating it was a high point in her life when she was first able to ride him.

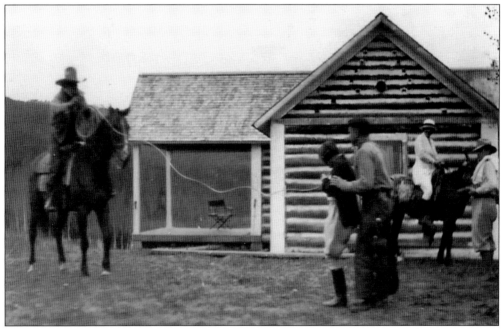

Charles F. Ayer was a member of the 101 Club, now called the Rio Blanco Ranch. He owned the Scenery Gulch Ranch down the White River; Verne Caldwell managed it for him. This photograph is of Verne Caldwell at the 101 Club, roping a girl for fun. The picture was likely taken in 1931 or 1932, as the Caldwell family lived there those summers. (Courtesy of the Caldwell Family.)

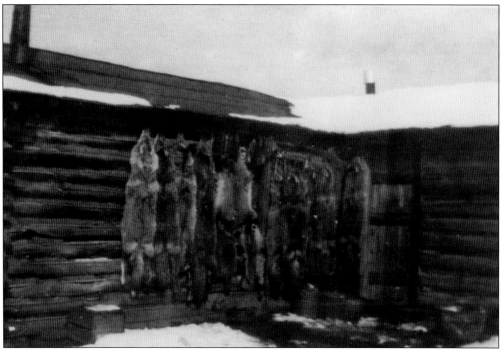

Coyotes have always been the enemy of the rancher. Here, coyote skins are hung outside a log cabin. This was taken north of Meeker on land that belonged to Paul and Helen Jensen and is now owned by the state as the Jensen State Wildlife Area.

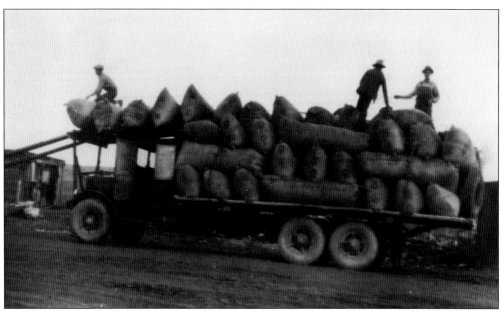

A wool truck in the 1930s is hauling out loads of wool to the market after shearing. The sheep industry, which was at one time vital to the economics of Colorado, remains active in the White River Valley. Longtime families like the Halandras and Theos still keep this ancient industry alive today by providing lamb and wool to the market.

The Fourth of July celebrations were officially named Range Call in 1938 when the festivities were expanded by adding events including what was called at the time the Pageant of the Meeker Massacre. In this first Range Call booklet, the pageant was described as a spectacular event put on by the American Legion Auxiliary showcasing the early history of Rio Blanco County from the Dominguez and Escalante expedition up to the Meeker Massacre. (Courtesy of the Museum of Northwest Colorado.)

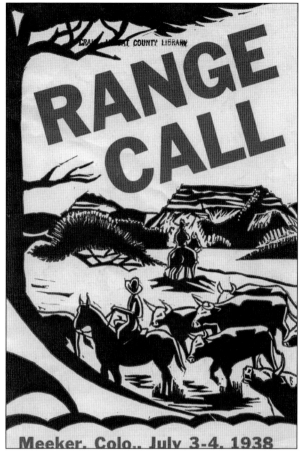

This c. 1920 photograph, taken by Cartright of Meeker, is of a group of vacationers at the Forest Inn at Trapper Lake.

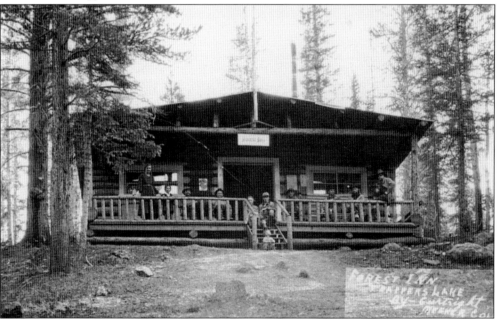

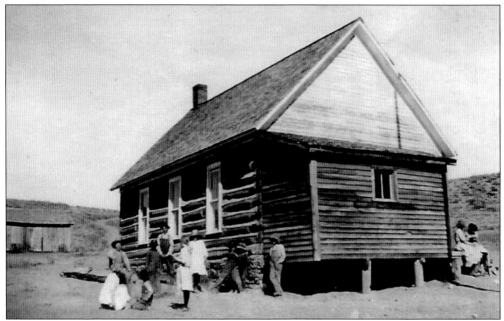

The Little Beaver School, a 20-by-30-foot log building, was constructed in 1909 by the Little Beaver community. The building was used for more than just teaching, as most rural schools were; it was also a social center and many dances were held here. Classes were held here until 1948, and the building still remains as of 2014.

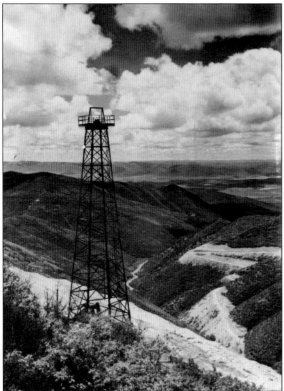

The Wilson Creek oil field, approximately 10 miles north of Meeker, was developed in 1938 by the Texas Company. At that time, it had the highest elevation of a producing oil field in the United States, and derricks were described as hanging onto the sides of mountains. The Texas Company built a camp, an airstrip, a school, and rows of cottages to house the families of oil field workers who they moved in to work in the field. The company provided gas heat, electricity, and hot and cold running water to the schoolhouse, which also served as a social meeting place. (Courtesy of the Museum of Northwest Colorado.)

Five

1940s AND 1950s

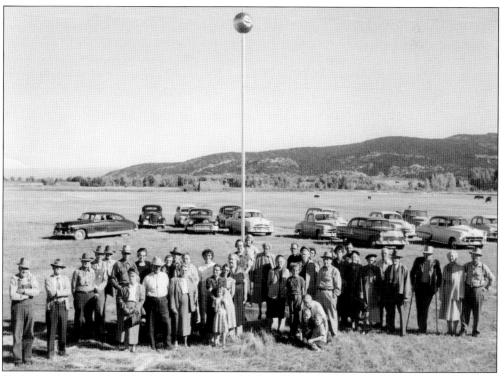

Here is a photograph of the historical-minded folks who in the 1940s erected the sphere at the site where the Indian Agency was burned down. At a pullout on the side of Highway 64 is a sign that Logan Kirkpatrick made in the same decade; from this sign the sphere is visible and is still there as of 2014. The 1940s were a time for continued remembrance of the past in Meeker; this was when the Rio Blanco County Historical Society was founded. The 1950s were more focused on moving into the future, and that is where this book leaves off. Many of Meeker's wonderful events and celebrations, like the Meeker Classic Sheepdog Trials and the Afterbirth Ball, were not started until later decades and so are not included here.

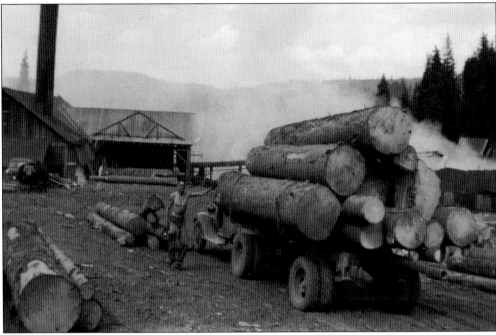

This scene is at Rippeys Mill, where loads of logs from the White River National Forest are being brought into the mill in the summer of 1940.

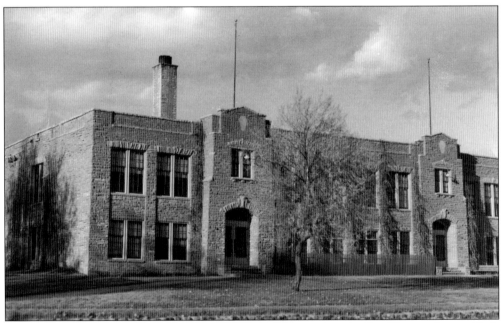

This building on Garfield Street was built in 1924 and served as the Rio Blanco County High School until 1955. It then became Meeker Junior High School when Meeker High School was constructed. It later served as a middle school and then an administration building when Barone Middle School was constructed in 1977. The building was placed on the State Register of Historic Places in 1993.

The White River Plateau Timberland Reserve, approximately 1.2 million acres, was established by the proclamation of Pres. Benjamin Harrison in 1891. Its golden anniversary was celebrated in October 1941 and many events were held in town to commemorate it.

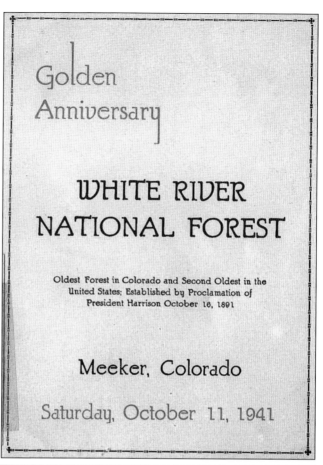

Golden Anniversary

WHITE RIVER NATIONAL FOREST

Oldest Forest in Colorado and Second Oldest in the United States; Established by Proclamation of President Harrison October 16, 1891

Meeker, Colorado

Saturday, October 11, 1941

This postcard image is an overview of Meeker from 1957.

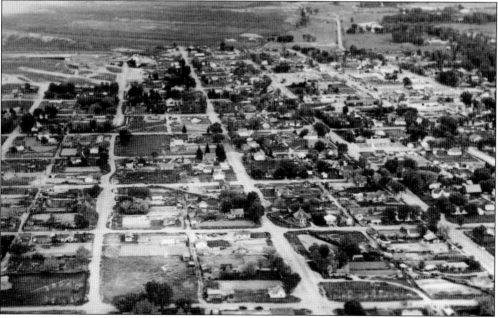

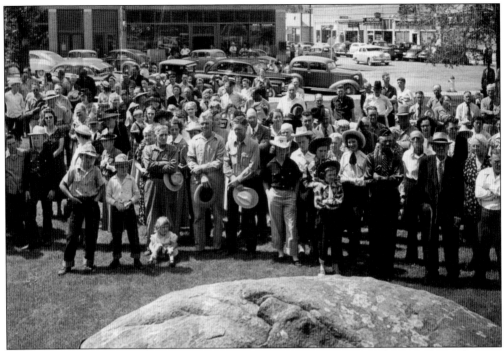

The Founders of Meeker plaque was installed on a monument stone on the courthouse lawn in 1949. This was the dedication ceremony honoring the pioneers who first settled this wonderful place. The plaque lists George S. Allsebrook, Charles S. Attix, Thomas Baker, William H. Clark, John C. Davis, Charles Dunbar, Samuel Fairfield, W. Harry Goff, A.J. Gregory, Henry H. Hay, George S, Hazzen, J.W. Hugus, James Kendall, James L. McHatton, Newton Major, Frank E. Sheridan, G. Dana Thayer, Eddie P. Wilber, and the sole female, Mrs. S.C. Wright.

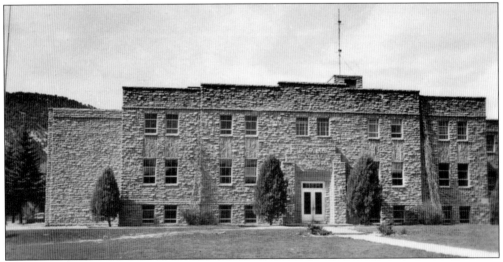

This is the Rio Blanco County Courthouse, which, along with Meeker Elementary School next to it, is a later addition to downtown Meeker. They sit on land that had originally been the parade grounds when this area was a military camp. When the town was first planned out, both blocks were set aside as a park area and enclosed with a picket fence. The courthouse was a WPA (a New Deal agency) project and was constructed in the late 1930s out of locally quarried sandstone.

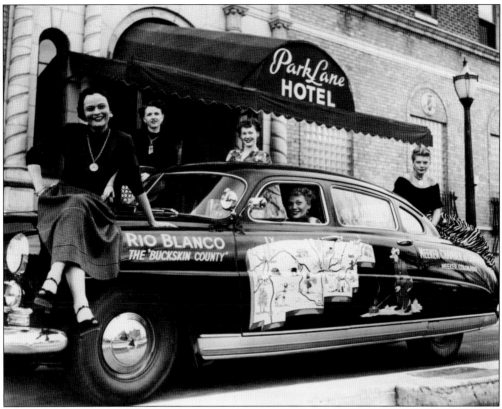

The Meeker Chamber of Commerce was trying hard to showcase Rio Blanco County in this *Denver Post* photograph from 1949. The 1950 Hudson Pacemaker is painted with a map of the "Buckskin County" and adorned with, from left to right, models Marty Frank, Than Weller, Jeanne Stewart, Helen Porter, and Maurine Howard outside the Park Lane Hotel. (Courtesy of the Museum of Northwest Colorado.)

Everyone in Meeker knows the name of Freeman Fairfield, who grew up in Meeker and then, through hard work and tireless spirit, made a sizable fortune. Fairfield credited his success to the early pioneers of Meeker who gave him guidance and encouragement while growing up, and wanted to give back to the town that raised him. Fairfield worked with the county commissioners to start Pioneers Medical Center in 1950. The Freeman Fairfield Charitable Trust was set up in 1969 and awards scholarships each year to college students.

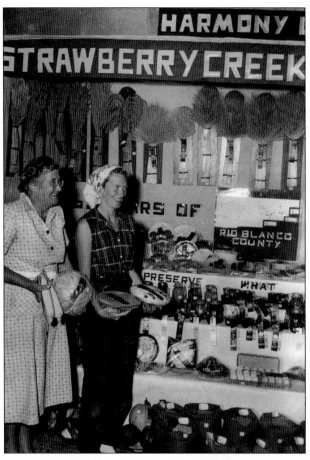

Featured in this *Denver Post* photograph are Margaret Davis and her mother-in-law, Mrs. Gene Davis, holding baked goods and produce fair entries. Their home goods were at the fairgrounds on display in the Harmony Club booth, which took first place at the Rio Blanco County Fair in 1954. (Courtesy of the Museum of Northwest Colorado.)

This c. 1955 black-and-white postcard of Meeker's first firehouse was made from a D'Ages photograph. The firehouse was on the corner of Seventh and Market Streets.

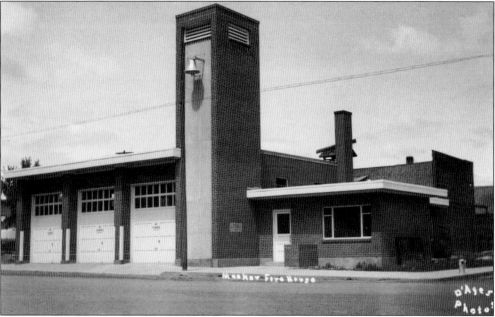

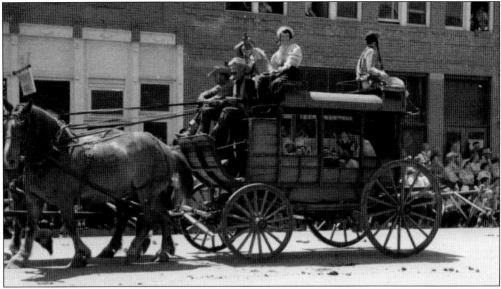

This 1950s Fourth of July parade entry showcases the historic Concord stagecoach—which had been owned by Simp Harp and is now owned by the Rio Blanco County Historical Society—going down Main Street. Norma Oldland, Carrol Bills, Dick Hilke, and Freddie Gordon ride the stagecoach in their old-time garb.

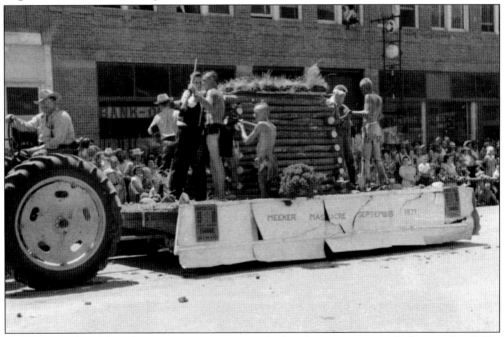

Meeker boys dressed in their pageant costumes, as Indian braves, on a parade float in the 1950s. While dressing up as Native Americans is now seen as politically incorrect in the United States, the pageant began as a way to showcase and honor the history of the area. When Wilda Woods was directing, she had those playing the parts of Indians practice their horsemanship and acting for months to perfect the important part. The first two years she actually used the CCC Camp Meeker men for the roles.

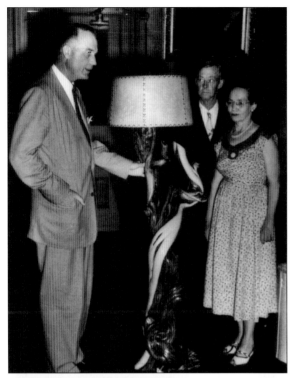

The 33rd governor of Colorado, Dan Thornton, is seen here with Dick and Sara Lough and their gift to the president. The Loughs pose with the lamp they made as a gift from the town of Meeker to Pres. Dwight Eisenhower and First Lady Mamie Eisenhower during the president's first term in office.

Shown here are Meeker pioneers being honored at the Fourth of July celebration in 1955. In the car is W.D. Simms. From left to right are (first row) Bessie Jones, Ed P. Wilber, Ida Baldauff, Nina Boise, Mrs. Hefley, and Kitty Fairfield; (second row) Fred Riley, Maggie Cassidy, Bob Mathes, Ed Boise, Claude Goff, Gertrude Graham, Fred Nichols, Ollie Duckett, and Mrs. Nichols.

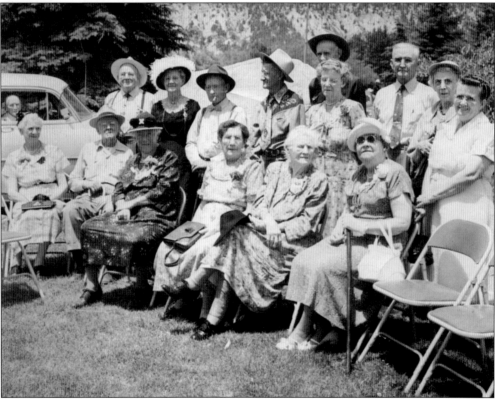

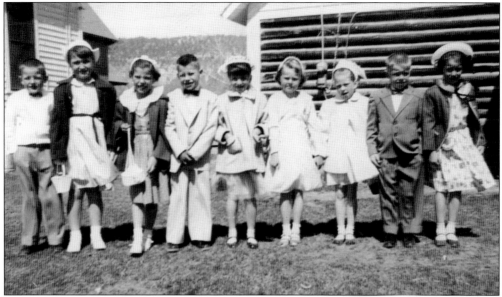

These children are dressed in their best for the Saint James Sunday school Easter party in 1956. From left to right are Joe Sullivan, Charlotte Sizemore, Anne Bloomfield, Alan Simillion, Lynn Story, Billy Jean Spence, Sally Holland, Joe Spence, and Kathleen Rose Conrado.

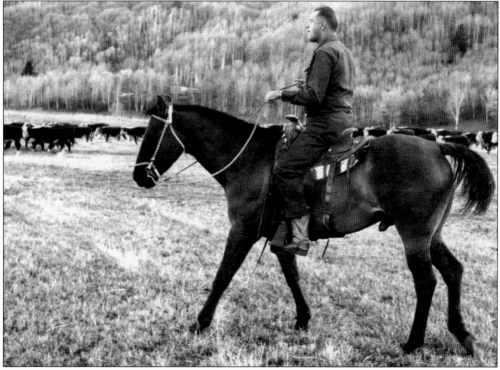

Elliot Roosevelt, son of Franklin Delano Roosevelt, is riding a horse and working cows on his family's ranch near Meeker in 1958. Two years after this, Roosevelt planned a multimillion-dollar resort for the rich upriver, however, it ended up being ahead of its time and did not pan out. (Courtesy of the Museum of Northwest Colorado.)

INDEX

ABOUT THE AUTHOR

Author Kristin Bowen is an archaeologist with the Bureau of Land Management who has worked in Colorado, Montana, New Mexico, and Nevada. Bowen received her Master's degree from the University of Montana in anthropology, writing her thesis on overseas Chinese in Virginia City, Montana. She is a member of the Register of Professional Archaeologists, Colorado Archaeological Society, Society for Historical Archaeology, and the Rio Blanco County Historical Society. She enjoys doing public education and interpretation, sharing archaeology and history with everyone.

ABOUT THE RIO BLANCO HISTORICAL SOCIETY AND WHITE RIVER MUSEUM

RBCHS preserves the rich heritage of the White River Valley by capturing oral history, maintaining collections of the local pioneers along with historic sites, and providing historic education on many topics to serve the community and all those who travel to this area.

The White River Museum itself is housed in two of the log buildings from the 1880s that served as officers' quarters of the federal troops stationed in Meeker. One of the last curio museums in Colorado, it is filled with collections ranging from the 1880s to the 1950s.

Located at 565 Park Avenue in Meeker, the museum is open daily year round. Admission is free and donations are always appreciated.

www.rioblancocounty.org
970-878-9982

DISCOVER THOUSANDS OF LOCAL HISTORY BOOKS
FEATURING MILLIONS OF VINTAGE IMAGES

Arcadia Publishing, the leading local history publisher in the United States, is committed to making history accessible and meaningful through publishing books that celebrate and preserve the heritage of America's people and places.

Find more books like this at
www.arcadiapublishing.com

Search for your hometown history, your old stomping grounds, and even your favorite sports team.

Consistent with our mission to preserve history on a local level, this book was printed in South Carolina on American-made paper and manufactured entirely in the United States. Products carrying the accredited Forest Stewardship Council (FSC) label are printed on 100 percent FSC-certified paper.

MADE IN THE
USA